iPad

FOR PHOTOGRAPHERS

Ø 52mm

18-55mm 1:3.5-5.6

iPad

FOR PHOTOGRAPHERS

ILEX

First published in the UK in 2012 by
I L E X
210 High Street
Lewes
East Sussex BN7 2NS
www.ilex-press.com
Copyright © 2012 The Ilex Press Limited

Publisher: Alastair Campbell
Creative Director: Peter Bridgewater
Associate Publisher: Adam Juniper
Managing Editors: Natalia Price-Cabrera and Zara Larcombe
Editor: Tara Gallagher
Art Director: James Hollywell
Designer: J C Lanaway
Colour Origination: Ivy Press Reprographics

British Library Cataloguing-in-Publication Data
A catalogue record for this book is available from
the British Library.

ISBN: 978-1-907579-77-6

Printed and bound in China

10 9 8 7 6 5 4 3 2 1

CONTENTS

Photographers were always going to be drawn to the iPad. With its lustrous screen and obvious portability, few had difficulty in imagining it replacing their weighty portfolios. Looking past the gloss though, for a photographer shooting on any camera apart from the functional built-in cameras on the iPad 2, the asking price might seem a little steep for a mere digital picture frame, however beautiful. In fact, the iPad, constantly developing and evolving through the apps available on its App Store, is far more than that, and this book will aim to show you just how much more.

Combine an iPad with the information on these pages and you will end up saving time and money: it's as simple as that. I don't promise to work miracles, but the information found within this book should enable you to use your iPad as a virtual assistant, a portable editing suite, and a top-notch previewing tool and storage device. When you imagine the total cost of all these individual elements, the iPad doesn't seem that expensive at all.

Changing technology

Viewing photos on an iPad is a magical experience, and those with their finger on the technology pulse have quickly realized this fact. The ability to literally reach out and touch a photograph on the iPad's screen, move it about, and smoothly zoom in and out of it provides a level of photographic interaction that harks back to the bygone era when light boxes and prints were the staple image viewers. Some might say this was photography's golden era.

Times and technology are changing, however, with an increased push into digital techniques across all aspects of the photography process. While the principles behind a great shot remain the same, the ways in which images are taken, developed, edited, and perhaps most importantly, viewed, are constantly adapting and improving. The speed with which images can be processed, edited, and shared is far faster than ever before, with larger memory cards, high-speed Internet connections, more advanced software, and social-networking services all playing their respective parts. The iPad sits high on the list of new technology and is quickly becoming the ultimate digital accessory for the modern photographer. From providing an excellent image review tool in the field to acting as the ultimate in portfolio viewers, the iPad has a lot to offer. This book aims to outline just how useful Apple's device can be.

The perfect photographic tool

Having owned an iPad from day one, and having racked up an unhealthy number of hours downloading and using the latest software in my former role as a magazine editor, I've learnt much about how the power of the iPad can be harnessed by digital photographers. And in this book I've aimed to condense all of this information. Working for creativity-focused magazine titles for much of my life, I've long been intrigued by the many ways in which the iPad can become a workflow-enhancing super tool for today's working creative. In this book, I hope to bring digital photographers up to speed with this exciting new technology and show how to turn it from an expensive gadget into an indispensable photographic aid.

Small and light enough to travel with you to even the most demanding locations, and powerful enough to handle image editing and sharing, the iPad looks set to become a much sought-after tool for creative professionals.

Covering the basics of photo importing and sharing through to more advanced editing and shooting tips, I'll be explaining essential techniques and uncovering applications that will improve the way you work. Whether you already have an iPad and want to make the most of it day-to-day, or you're in the market for an all-in-one tool to speed up and enhance your workflow, *iPad For Photographers* will provide the answers you need.

A wider world (partially cloudy)

On top of the other connectivity options which will be discussed within these pages, an iPad, especially if it's your first Apple product, is also a step into the wider world of the iCloud service. This is a boon for photographers keen on both securing their images and sharing their data, and we'll look at both of those features—and more uses of the mobile internet—within these pages.

ABOVE Photos always look better on the iPad. Sadly, not in this case.

Accessory overview

While writing this book I've been in close contact with a number of developers who produce software for the iPad that enables photographers to do more and in less time. Many have contributed valuable information and clever tips and tricks that will push the boundaries of your iPad's capabilities and I heartily recommend their apps to anyone serious about photography.

Among these additional applications you will find two apps from the team at Avatron Software, namely Air Sharing HD and Air Display, Portfolio To Go by Nick Kuh, and Photogene for iPad by Omer Shoor. None of these downloads will break the bank, but they will all offer you many more options than your iPad can provide in its default form, and each will be worth the investment in the long run. The apps are also regularly updated, so having made the initial payment, you will see new features added as you continue to use these apps day-to-day.

As well as software, I've also recommended some essential accessories for iPad users. Whether they protect the device from damage or help with routine tasks like charging, you should certainly check them out if you intend to use your iPad when away from home on a regular basis. But before you balk at paying any more than the already substantial amount you have paid for your iPad, fear not, this is where the hidden costs end.

THE BASICS

Before we delve too far in, it's important that we look at a few basics, the principle of which is that the iPad is subject to changes, and it would be foolish to pretend otherwise. To that end we're providing a web address which we'll update with notes if Apple make any significant changes to the iPad, for example by a software update, that could affect this book. We'll also list any cool apps that have sprung up since we compiled the list in the book (but the ones here are already pretty fantastic).

iPad and iOS

Like a computer, the iPad has, at its core, an operating system—underlying software that drives it, allowing other features and apps to work. It provides the screens that let you switch between apps, but just as crucially it provides the tools apps need to connect to the features of the iPad, like the camera.

From time to time, Apple update the software and, usually, older systems can take advantage of many of the new features by simply taking advantage of a free download. For example, with the update to iOS5 both the first generation iPad and the newer one gained useful features like access to the iCloud, and Twitter integration, but improvements to the Camera tool were only available on the iPad 2 as there is no camera on the original iPad.

...the original iPad did not have a camera...

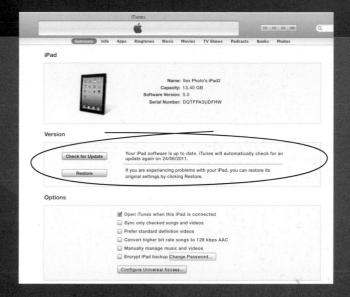

RIGHT Older versions of iOS could only be updated by plugging into a computer and downloading the update using iTunes. You might also need to update iTunes, too. iOS5 requires at least iTunes 10.5.

This might all seem like old news for people used to updating their software, but many people simply never do so. They activate their iPad (or iPhone), then never connect it to the computer again, missing out on free new features (as well as security improvements).

If you're not sure what version of iOS you have, see the instructions below to find out. In this book we'll assume that you have at least iOS5. After iOS5 updates should be possible whenever you've got an Internet connection, but if your iPad version number is 4.(anything) you'll need to connect it to your computer and use iTunes to perform the upgrade. From then onwards you'll be able to add any updates that Apple provide without the need for a desktop computer.

Reach for the skies
iCloud stores files and distributes them between your devices so that the most up-to-date version appears wherever you are, whether you're checking your phone, your computer, or, of course, your iPad.

To take advantage of these tools, Mac users do need to upgrade to Mac OS X 10.7 "Lion" or later, while users of Windows 7 onwards should visit apple. com and download the most recent version of iTunes and the iCloud Control Panel. The latter allows your PC to receive pictures from your iPad the moment they're taken (iPhoto performs a similar function on a Mac).

Of course, like all network-based services, you'll need an account and a password before you can get going, but once you've set that up on both your computer and your iPad (and your iPhone, come to that), you'll find it all works close to magically.

The Photo Stream feature is not limited just to the iPad's built-in camera either, so you'll be able to transmit images from any app that uses the iPad's (or iPhone's) Photo cataloging functions. Straight out of the box that includes the Photo Booth tool, but other great photo apps are also included.

SETTING UP

On the last few pages, we talked about some of the new technologies that the iPad puts into your hands. Now we'll have a look at what you need to do to get going. We'll start right from the beginning, as if you'd just acquired a shiny new iPad, but if you've already completed some of these steps, then skim through the text and jump in where you need to.

This is my first ever Apple device, and I've never used iTunes

Really? Well, welcome to the party, as they say. Actually you've got something of an advantage, as you'll only need to set up one account, you won't need to "migrate" any information from other accounts. You will be guided through the process, and can choose either to associate it with an email account you already have, or to take advantage of Apple's free email service (with an @me.com address). It's probably better to use your normal email address though, as your Apple ID will be associated with your credit card (or debit card) too, so you can make purchases.

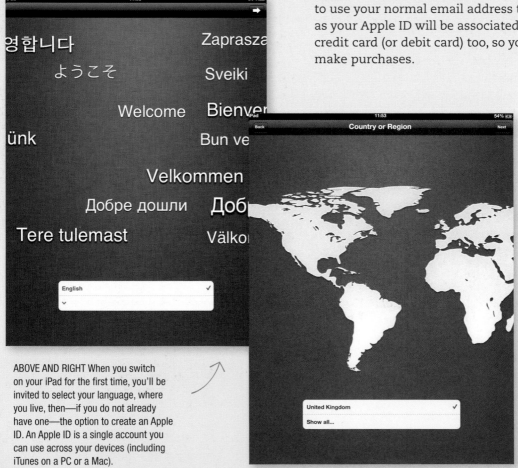

ABOVE AND RIGHT When you switch on your iPad for the first time, you'll be invited to select your language, where you live, then—if you do not already have one—the option to create an Apple ID. An Apple ID is a single account you can use across your devices (including iTunes on a PC or a Mac).

I already use iTunes to buy music or apps

This might mean you've got an iPhone or iPod and use that to buy apps and music, or it might just mean your favorite online record store is iTunes for Windows. In any case, it means you've already got an Apple ID, so for the sake of convenience it would make sense to use that one. After all, the point of all the lovely cloudy connectivity is that we're sharing data between our devices.

You'll find your Apple ID at the top right of the window in iTunes, so you can copy this into your iPad and (if you've forgotten your password since setting the account up) there's an amusingly named "iForgot" tool to put things right.

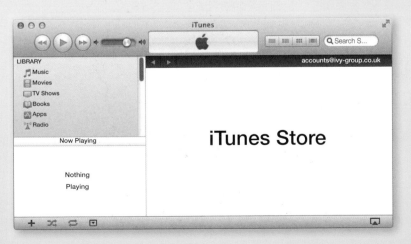

LEFT If you already use iTunes, your Apple ID is shown here in the top right of the display area when you're browsing the iTunes Store.

:SETTING UP

Cloud services back home

Once you've got an Apple ID, you're ready to buy, but there's more to it than that. The Apple ID is also your link to iCloud services, and they work a whole lot better if your computer knows where to look.

RIGHT Creating an account with the iCloud service will allow you to use your iPad to its maximum potential.

iCloud

On a Mac

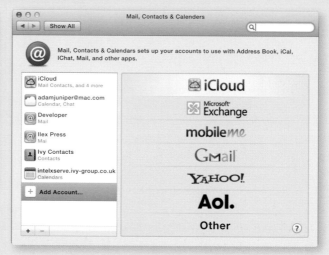

 1 In Mac OS X "Lion" or later, open the System Preferences panel (via the Apple symbol), and choose Mail, Contacts & Calendars

2 Choose iCloud from the list on the right to set up a new account (or, if there is already one on the left, check it is correct).

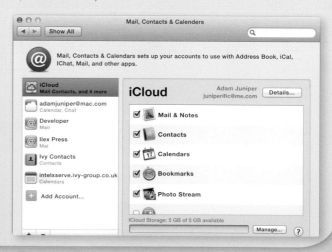

3 Once you've selected iCloud from the list, check to ensure Photo Stream is switched on.

On a PC

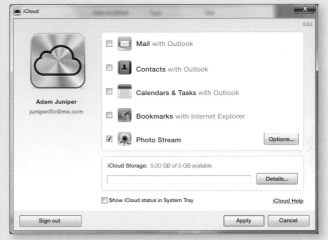

1 If you use Windows, you'll first need to go to www.apple.com/icloud and download the iCloud for Windows tool.

2 Follow the on-screen instructions and either sign in with your Apple ID or create a new one. Then, when you see the settings screen, ensure that the Photo Stream button is checked (switched on).

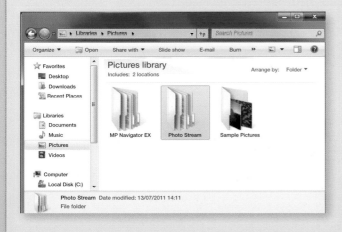

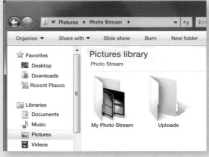

3 This creates two folders in the location of your choice (by default the Pictures folder), one which receives pictures from your iPad, and the other which sends them to it.

IMPORTING PHOTOS

The iPad would be a nigh-on useless tool for the photographer without a way to add photos to the device. Obviously, the built-in camera in the iPad 2 is one method; however, its quality leaves something to be desired. It's good to know, then, that there are multiple ways in which images from your camera can be transferred to the iPad and accessed, either by way of the built-in Photos app or through third-party photo applications. These include Wi-Fi and USB connections to a computer, or using Apple's own Camera Connection Kit to transfer images directly from a camera in the field. If you plan to use the iPad as a review tool it makes sense to get hold of this accessory, which is available at Apple Retail Stores and resellers. If you prefer to transfer photos from a computer, the iPad is compatible with both Mac OS X and Windows, using iTunes to select which photos are sent to the iPad's Photos app. In this chapter we will also explore other photo transfer options, including wireless and web-based transfers.

...multiple ways in which images from your camera can be transferred to the iPad...

One of the first things you need to consider before transferring your photos to the iPad is just how much storage space you have. For smaller capacity iPads this could mean trouble if you plan to copy over Raw images or even large-format JPEG shots. Once you take into consideration the space taken up by applications, as well as media and email attachments, it's no surprise that a small iPad can fill up fairly quickly.

To quickly see how much space is available on your iPad you can access a breakdown from the Settings app on the iPad home screen. This view lists all of the media present on your iPad and also gives a reading of the capacity and available capacity for the drive. A tutorial on how to do this can be found over the page. As you will likely notice, the available capacity isn't quite what was detailed on the iPad's box to begin with. The 16, 32, or 64GB capacity listed for iPad models does not include system software or pre-installed apps, so you never truly get access to the full amount. It's for this reason that you should rid your head of the "claimed" storage capacity and focus on the real information found on the device itself, or you'll likely end up with error messages explaining that not all of your images could be transferred. Another way to view the available space on your iPad is to connect it through USB to your computer. Once connected, you can access the iPad through iTunes, where a colored bar shows not only how much space is available but what types of file are eating up the capacity. This makes

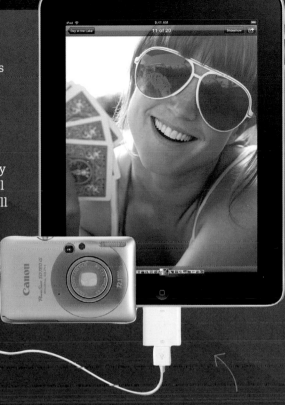

ABOVE Apple's Camera Connection Kit allows you to add images to your iPad without the need for a computer.

it easier to weed out unnecessary files to make room for your images.

Cleaning out unwanted files can save you valuable space, as can moving photos to either Apple's iCloud or an alternative service should your needs demand it. By combining your iPad's built-in storage space with a web-based facility, you can be far more flexible when it comes to accessing and sharing your images. You could, for example, store your priority pictures on the iPad, and secondary shots on the web. The free Dropbox service offers a neat solution for storing and sharing images, and is explained in detail at the end of this chapter.

SPACE AVAILABLE ON YOUR iPAD

Find out how much space is available on your iPad

1 From the iPad's home screen, tap on the Settings app to launch it. Now tap on the General button.

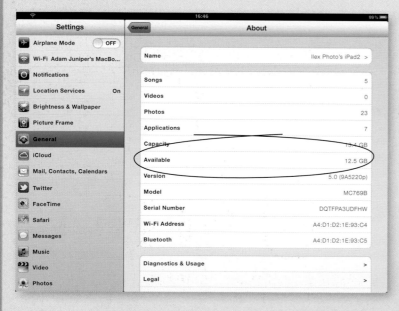

2 From the list on the right of the General Settings screen, tap on About to find out more information regarding your iPad. The screen reveals how much of a type of media is on your iPad, the capacity of your device, and the available space. You're also shown how much space you have left in your iCloud backup space.

See what's taking up iPad space using iTunes

1 Start by connecting your iPad to your computer using the USB cable supplied with your device. If it hasn't launched automatically, load iTunes and select your iPad from the source panel on the left-hand side of the interface.

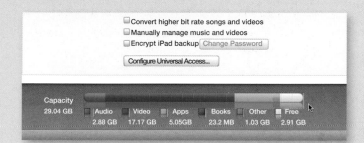

2 The screen that appears in the main iTunes window features a colored bar that shows the capacity being used by the different types of media on your device as well as the amount of free space.

TRANSFERRING FROM A CAMERA

Transferring photos from a camera

It's nothing new to be able to move pictures you've taken from a camera to a computer, and we're all used to this very simple process. The iPad is a different beast, however, and therefore does not offer the USB ports that allow for the direct transfer of photos from a camera to a hard drive. While most people would be content to transfer pictures from their camera to their computer and then sync them to their iPad, this doesn't necessarily work for the photographer, especially if they find themselves working in the field without a computer present. Luckily, Apple offers a way to skip the computer step with its Camera Connection Kit, which allows photos to be added to the iPad through a USB connection to the camera, or direct from an SD card. The iPad supports standard photo formats including JPEG and Raw files, so compatibility shouldn't be an issue, either.

Using the USB

The kit comes in two parts. One adapter connects to the dock connector port at the bottom of the iPad and then connects by way of a USB cable to a camera, while the second adapter allows for an SD card to be inserted and read through the connection kit. Once either of the two adapters are connected, the iPad's Photos app launches and shows all available images on the iPad's screen. You are then free to pick the images you want to import up to the size of your iPad's available space. When images are imported from a camera they are automatically organized into albums based on the metadata in each

photograph. These images are then stored on the iPad, leaving you free to empty your camera's memory card and carry on shooting. This is an extremely handy feature if you're taking many shots or only have a small-capacity memory card to hand.

iPad as intermediary

While the transferred images remain on the iPad, they will be automatically transferred to your computer's photo library the next time you sync. Using the Camera Connection Kit, the iPad behaves as a useful intermediary between your camera and computer, offering more space for photos than a memory card, and a safe place to store images before they are transferred to your main library. It also gives you a way to show images to a client while on location or in the studio without having to hook up your camera or card to a computer. We'll cover sharing photos, along with tethered shooting, later on.

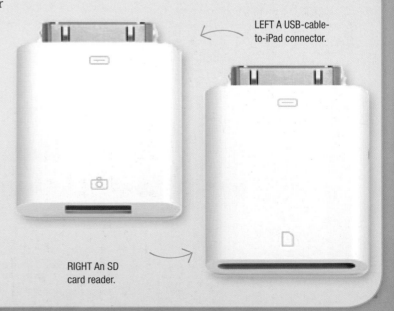

LEFT A USB-cable-to-iPad connector.

RIGHT An SD card reader.

Transfer photos from a camera to an iPad through USB

1 Connect Apple's Camera Connector part of the kit to your iPad using the Dock Connector on the bottom of the device. Now connect your camera to the USB cable and set your camera to transfer or hard-disk mode if it hasn't already done so automatically.

2 The Photos app will now quickly appear on your iPad as the device quickly downloads previews, from which you can select the photos you would like to import (or import all).

TRANSFERRING TO AN iPAD

Transfer photos to an iPad via SD card

1 Connect Apple's SD Card Reader to your iPad via the Dock Connector port.

2 Insert your SD Card into the Card Reader to launch the iPad's Photos app which will then read the SD Card.

3 Select the images you wish to transfer from the SD Card using the Photos app to save them to your iPad's photo library.

TRANSFERRING FROM A COMPUTER

Transferring photos from a computer

The quickest way to get your existing photographs onto your iPad is by syncing it with iTunes. You can sync photos in the same way you move applications, music, and movies to the device by simply connecting your iPad to your computer and letting iTunes do the work for you. Of course, you'll first need to tell it which photos you want to transfer and where they are stored. There are a number of different ways to perform photo syncing depending on the platform and software you are using, but once set up, your iPad will continue to be updated each time you plug it into your computer.

Syncing makes it easier to ensure you always have your latest and best photos with you, too. By selecting a specific folder on your hard drive, or in a desktop app like iPhoto or Aperture, you can add new images to it whenever you need to and they will be automatically transferred to your iPad the next time it's synced.

Another method, ideal for getting some pictures on your iPad quickly to show someone else, is to drag them into your PhotoStream, which is then shared to all your iCloud devices. You can do this in iPhoto, or on a Windows computer using the uploads folder you created when you set up iCloud (see page 12).

iTunes

RIGHT The iPad makes an ideal portable viewer for your images and offers slideshows to further enhance your shots.

IMPORTING FROM A MAC

Transferring photos to a MAC with iTunes

iTunes

iPad sync is complete.
OK to disconnect.

Music
Movies
TV Shows 4
Podcasts 7
iTunes U 24
Books
Apps 96
Ringtones
Radio

STORE
iTunes Store
Purchased
Purchased on Ben Harvel...
Purchased on Ben Harvel...

DEVICES
Ben Harvell's i...
Ben Harvell'...

Genius
Genius Mixes

| Summary | Info | Apps | Music | Movies | TV Shows | Podcasts | iTunes U | Books | Photos |

iPad

Name: Ben Harvell's iPad
Capacity: 29.04 GB
Software Version: 3.2.1
Serial Number: GB016v1JZ39

Version

Update — A newer version of the iPad software is available (version 3.2.2). To update your iPad with the latest software, click update

Restore — If you are experiencing problems with your iPad, you can restore its original settings by clicking Restore

| Summary | Info | Apps | Music | Movies | TV Shows |

☑ Sync Photos fr ✓ 🖼 iPhoto
 ● Aperture

● All photos, albums, Choose folder...
○ Selected albums,ev 🖿 Pictures matically include [no e]

☐ Include videos

1 Connect your iPad to your computer using the provided USB cable. Connect one end to the iPad's dock connector socket and the other to an available USB slot on your computer. iTunes should now launch if it's not already open. If it doesn't launch automatically, do so manually. Now select your iPad from the source menu on the left of the iTunes interface.

☐ Family
☐ Vehicles
☐ San Fancisco
☐ Fishing Boats
☐ Friends and Sports
☐ Abstract
☐ Vacations
☐ Gardens
☐ Pier
☐ Portraits
☐ Effects & Editing

2 Click on the Photos tab at the top of the screen and check the Sync Photos from box. Now just select the application in which you keep your photos from the pull-down menu.

3 All of your albums and events should now be listed within iTunes for you to select. Choose to sync all photos, or a selection from your library, and click the Apply button to begin the transfer.

Cancel

Apply

| ☐ Photos | Apps | Books | her | Fle |
| 775 MB | 5.05 GB | 23.2 MB | 1.02 GB | 2.16 GB |

IMPORTING FROM A PC

Transferring photos to a PC with iTunes

1 Connect your iPad to your computer using the provided USB cable. Connect one end to the iPad's dock connector socket and the other to an available USB slot on your computer.

STORE

iTunes Store

Ping

DEVICES

▶ Adam Juniper's iPad

SHARED

Home Sharing

GENIUS

2 iTunes should now launch if it's not already open. If it isn't, launch it manually, then select your iPad from the source menu on the left of the iTunes interface.

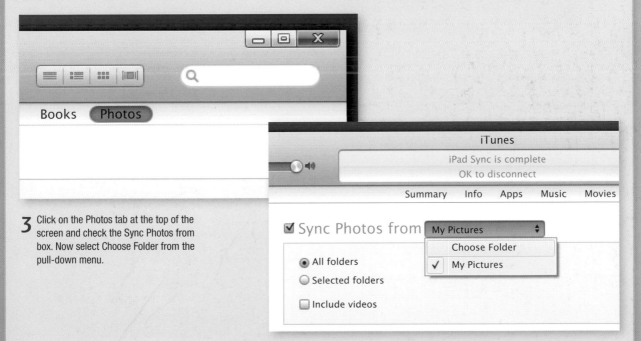

Books **Photos**

iTunes

iPad Sync is complete
OK to disconnect

Summary Info Apps Music Movies

☑ Sync Photos from My Pictures ⬍

● All folders Choose Folder
○ Selected folders ✓ My Pictures
☐ Include videos

3 Click on the Photos tab at the top of the screen and check the Sync Photos from box. Now select Choose Folder from the pull-down menu.

4 Locate the directory in which your photos are stored and click on Select Folder to add it to the list. Now select individual folders of photos or select them all and click the Apply button to begin the transfer.

IMPORTING PHOTOS

Importing photos from email and the web

As well as a brilliant tool for viewing the web, the iPad also works as a great communication device, enabling you to connect to a range of email services. Attachments are also catered for with images appearing in-line in mail messages, or as a link, depending on how they were sent. You can, however, tell the iPad's Mail application not to download any images by turning the feature off through the iPad's Settings app. This is a useful technique if you're using a 3G network, especially if you have a capped amount of usage every month. By preventing automatic downloads you can wait until you have a Wi-Fi connection to download, and you will also get faster downloads over a fixed broadband connection than you will over a mobile data network. Images that haven't been downloaded from the remote server will appear as a small icon, which, when tapped, will begin the download.

Zipped files and folders

Some mail clients may compress images sent to you through email, so remember that their quality may be reduced when viewing or displaying them to others. Mail clients may also archive large collections of images and send them as a compressed .ZIP-format file. The iPad does not offer native support for compressed formats like .ZIP so you will need a third-party application to access them from Mail on the iPad. The inexpensive app GoodReader adds support for archived files, as well as a number of popular formats that don't work natively on the iPad. However, Air Sharing HD also provides the facility and should be your preferred option given the additional features (see page 27).

Saving an image

The iPad has a built-in system for saving images. Simply hold a finger down on an image and select Save Image from the menu that appears. You can also choose Copy to save the image to the clipboard for pasting into an email or another document. Most images on the web can be stored this way, but you may find that some are embedded as part of the site or are built as a web link so you won't be able to store them. Don't panic. If you really need an image you find on the web, you can use the iPad's built-in screen-grabber. Zoom into the image on the web page using the pinch method, then press the iPad's Home button and the sleep/wake button at the same time. The screen will flash and you will hear the sound of a camera shutter. The image will then be stored in your photo library.

RIGHT Zipped files and folders.

BELOW importing photos from email.

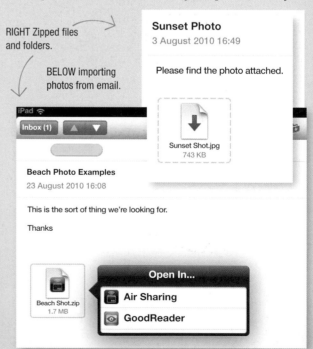

Save an image in an email to your iPad photo library

1 Start by opening the Mail app and selecting the message that contains the image you want to save.

2 If the image hasn't downloaded automatically, tap on the icon to begin downloading it. The progress of the download will be shown below the icon.

3 Once downloaded, the image will be displayed in the email message. Tap and hold your finger on the image until the menu shown appears.

4 From the menu, tap on Save Image. The image will now be transferred to your photo library and can be accessed from the iPad's Photos app.

SHARING PHOTOS WIRELESSLY

One feature request common to many iPhone and iPad users is the ability to wirelessly sync and share files from their computer to their device. Apple hasn't provided such a feature yet, but a number of third-party app developers have stepped in to fill the gap. The benefit of wireless syncing over the traditional USB method is that updates can be made automatically without any action required on the user's part, just as emails are synced with a central server and sent to your iPad and your desktop computer. Wirelessly sharing photos makes the whole process that little bit easier than doing it manually.

Most applications that offer wireless sharing create a shared folder between the iPad and a computer, allowing images to be dragged from the desktop and automatically accessed on the iPad without the hassle of attaching the iPad to a computer and jumping into iTunes. To use these features, both the computer and the iPad will need to be connected to the Internet, and in some situations, connected to the same network. While there are many options available, the two options below offer the cleanest methods and use two different wireless sharing disciplines.

Avatron's Air Sharing HD creates a local folder on your computer to transfer images over a network, while Dropbox offers free online web storage for your photos. You can access them on both your computer and the iPad and rely on the Dropbox software to keep both up-to-date. The method you choose depends on your circumstances and preferences when it comes to transferring files. If you're not happy to sync with iTunes every time you want to update the images on your iPad, then creating a wireless folder may not be for you. Remember though, that by using a web-based sharing option, you'll have access to these files wherever you have an Internet connection, not just at your desk. You'll hardly have to worry about syncing at all.

A final wireless sharing option is to make use of a special type of memory card called an Eye-Fi. Effectively a wireless SDHC card, the Eye-Fi and its corresponding software allows you to transfer images from a camera to a computer over the wireless network. For iPad users, the addition of a little piece of software called ShutterSnitch, easily found on the App Store, means you can apply the same technique with your iPad. With both your Eye-Fi card/Camera and iPad on the same wireless network, you simply tell ShutterSnitch your Eye-Fi username and password and it will grab images from the card and add them to your iPad.

RIGHT The Eye-Fi" card offers a clever way to send photos directly from a camera to a connected device.

Shuttersnitch

AIR SHARING HD

Air Sharing HD is a powerful app that enables you to take your photos and documents with you on your iPad with a minimum of fuss. Any Mac, Windows, or Linux computer can mount an Air Sharing HD as a wireless hard disk, making it easy to drag files between your computer desktop and the Air Sharing HD volume. Then you can view documents, transfer files between file servers, print documents wirelessly, and manage your files. The app can connect to a wide variety of file servers, including Dropbox, FTP or FTPS, SFTP (SSH File Transfer Protocol), and WebDAV. If you are familiar with Apple's Finder or Windows Explorer, Air Sharing HD's interface will feel very familiar. File and folder icons are presented on a desktop-style interface with folders for categorizing your documents. You can even browse into ZIP archives without uncompressing—a major bonus given that the iPad doesn't offer support for the ZIP format.

For photographers, Air Sharing HD's support for very high-resolution photos is a welcome feature. The iPad's built-in Photos app is a great image viewer, but it has been known to have issues when it comes across high-res images. Unlike Photos, you can also drag files easily and wirelessly into Air Sharing HD's folder hierarchy without having to sync your iPad to commit each transfer. Keeping your iPad mounted on your desktop with Air Sharing HD means that, even if you have to rush out, you can quickly drag your images to your iPad without having to sync all the other media stored on it, such as music, movies, and podcasts.

Air Sharing HD

RIGHT Sharing files wirelessly to your iPad isn't as tricky as it might sound, especially with apps like Air Sharing HD.

Drop Box

AIR SHARING HD ON A MAC

Connect and share photos with Air Sharing HD on a Mac

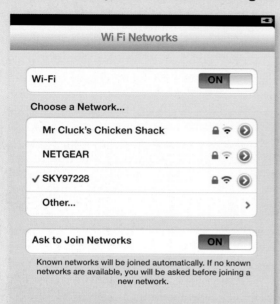

1 Open your iPad's Settings app and then Select Wi-Fi. Now pick the wireless network used by your computer from the list.

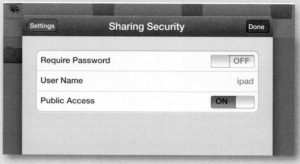

2 Now launch Air Sharing HD and tap on the wrench at the bottom right of the interface to bring up the settings menu. Tap on Sharing Security.

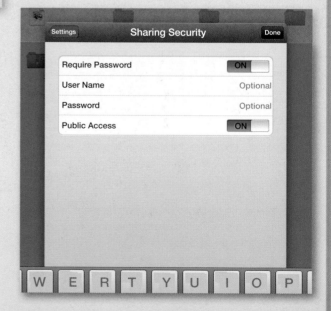

3 Add a name and password for your iPad to make sure it's secure when sharing wirelessly. You can also add a passcode to lock the application for additional security.

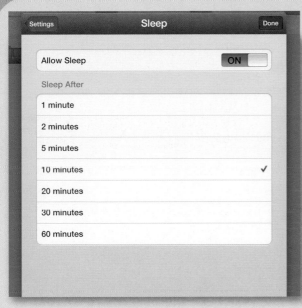

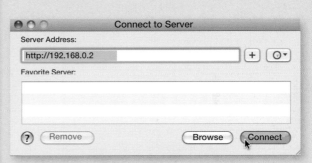

4 Turn on the Allow Sleep option to avoid communication problems if your device goes to sleep while mounted.

5 On your Mac, click on the desktop to make sure you are in the Finder and hit Apple+K to pick a server to connect to. The address you need for your iPad can be found in the Help section of the Air Sharing HD app under Mac OS X. Type in the IP address given and enter a password if required. Your iPad should now mount as a drive on your desktop.

6 Files can now be transferred to and from your iPad by way of your desktop by adding images to the mounted folder. Try dragging the folder to your Dock to access quickly in future.

AIR SHARING HD USING WINDOWS

Connect and share photos with Air Sharing HD using Windows Vista/Windows 7

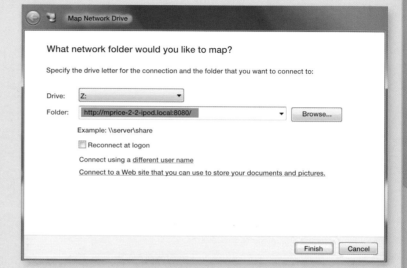

1 Follow steps 1 to 4 above, then open Windows Explorer and select Map Network Drive from the top of the window. Click on the Folder field of the My Network Drive window and enter the IP address or Bonjour name of your iPad. Click Finish and you should be connected.

2 If you don't know the IP address or Bonjour name of your iPad, you can find this info in Air Sharing HD by tapping the Wi-Fi symbol in the menu bar at the bottom.

Connect and share photos with Air Sharing HD using Windows XP

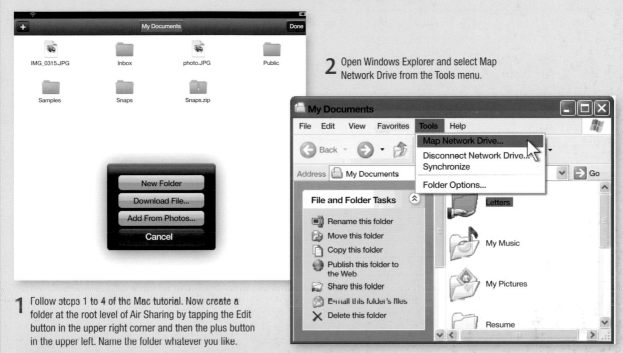

2 Open Windows Explorer and select Map Network Drive from the Tools menu.

1 Follow steps 1 to 4 of the Mac tutorial. Now create a folder at the root level of Air Sharing by tapping the Edit button in the upper right corner and then the plus button in the upper left. Name the folder whatever you like.

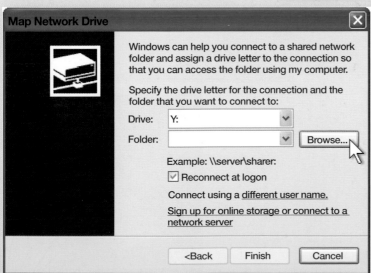

3 In the Folder field of the window that comes up, enter the IP address or Bonjour name of your iPad as listed in Air Sharing HD followed by the name of the folder you just created. For example, http://10.0.1.1/Documents. Click Finish and you should be connected.

USING DROPBOX

Using Dropbox

Dropbox is a free service designed to allow users to share files and folders across multiple computers and mobile devices, including the iPad. Dropbox effectively provides a single shared folder online, and all connected devices can access and edit this folder's contents, making it an ideal place to store your photos. The software constantly monitors your Dropbox folder and updates all devices connected to it accordingly. Edit a photo that is stored in your Dropbox folder using your computer, and the next time you access the same image on your iPad by way of Dropbox, it will show all the edits you made at your last visit. Similarly, if you're heading out to visit a client and you're taking your iPad, you can quickly drop relevant images into your Dropbox folder and they will be accessible as and when you need them. After signing up for an account at www.dropbox.com, you will have access to 2GB of storage, which should be more than enough for a few albums worth. If you need more, you just have to pay a monthly or annual fee.

Dropbox can be installed on as many computers as you desire, and all you need for your iPad is the free Dropbox app from the iTunes Store. Images opened from within the Dropbox iPad app can be transferred to the iPad's photo library or opened in another iPad application if required. The bonus here is that, whether you're using your desktop computer, a laptop, or your iPad, you can access the same library of images and make changes that will be reflected on each device you use.

The Dropbox app is universal too, so it can be used on an iPhone as well as your iPad. In addition to providing a unique way to access images on the iPad, Dropbox offers a number of additional benefits. Everything within your Dropbox folder is automatically backed up online, for example, offering you extra peace of mind, and you can also provide a link to your Dropbox to other users so that they can look at your images and be notified when you make changes. These collaboration options make it an ideal tool for photographers working in groups or for receiving feedback from clients with changes and updates to files in your Dropbox made almost instantly. When using Dropbox on the iPad, you do need to have an Internet connection to access your files but, if you think you might be caught short, Dropbox offers a Favorites feature that stores Dropbox files on your iPad for offline use.

Dropbox

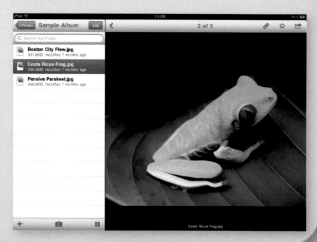

Share photos with Dropbox

1 Download and install Dropbox for your computer from www.dropbox.com, then visit the App Store and download the App for your iPad.

2 Follow the instructions to set up your account and access your Dropbox folder on your computer. Locate the Dropbox folder on your computer. This can be found in the User folder or via the menu bar on a Mac, and on a Windows system in the system tray or via the Start menu.

3 Select the images or folders you wish to add to your Dropbox folder and drag them into it. These images will now be available on all of your devices that have Dropbox running.

4 Launch the Dropbox iPad app and enter your Dropbox login details. Now press the button at the top left of the interface to access your Dropbox. Select the images you wish to view or the folder containing them. From this view you can flick through your images or save them to your iPad's Photos app. You can even email a link to your Dropbox images if you wish.

EDITING PHOTOS

Out of the box, the iPad doesn't have any image-editing tools available when accessing images from its photo library. While images can be viewed and shared, even the most basic of adjustments must be performed using a computer. There are, however, a great number of third-party applications that, for a minimal cost, will provide at least some of the editing options provided by desktop applications like Adobe Photoshop and Apple's Aperture. While no sensible photographer should give up their desktop-based editing suite for an iPad, the option to edit images in the field and quickly fire them out to clients and colleagues by way of email is of serious benefit. The iPad's display is also ideal for the task and, in many respects, better than a laptop screen or the LCD display found on a camera or preview device. Editing on the iPad can also boost your workflow, providing a chance to make adjustments while traveling between a location and the studio, or during any downtime.

...better than a laptop display or LCD display found on a camera...

In this chapter the focus is on two iPad photo-editing apps—one you'll have heard of and the other a relative unknown. Photoshop Express is Adobe's free photo-editing tool for iPad and offers some fairly basic features, but balances these limitations with its web-based capabilities that allow for sharing photos and online storage through a photoshop.com account, which you may already have set up. Photogene is an independent iPad image editor that offers a great range of features for a minimal fee. The two apps have their own merits and you'll have to sample both to find the one that's right for you, though the Photoshop Express's zero cost is a major selling point. Over the next few pages you will learn how to perform basic image edits with Photogene for iPad and how to access and adjust your photoshop.com images with Photoshop Express.

Photo Express

Photogene

RIGHT Inexpensive yet powerful, Photogene is a useful addition to your iPad's image-editing arsenal.

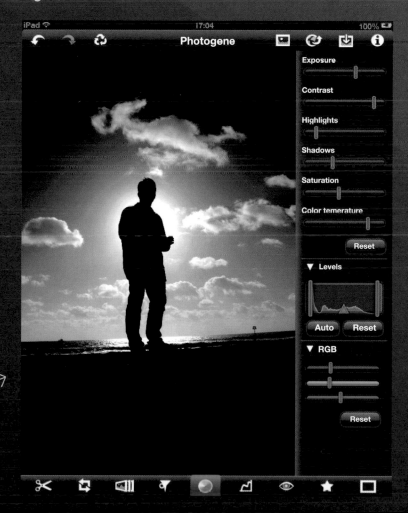

Photogene for iPad, developed by Omer Shoor, is arguably the best image-editing tool for the iPad at present. While there are a number of tools that do certain editing jobs well, Photogene caters for the most important tasks and handles them with aplomb, whether it's simple red-eye correction or more advanced retouching. The app is available from the iTunes App Store and offers an impressive array of tools to make alterations to your images on the fly. These pictures can then be synced back to your computer from the iPad for further editing, printing,or publishing.

Photogene

Share photos with Dropbox

1 Open an image from your iPad photo library, then tap on the Scissors button at the bottom left of the screen to start cropping.

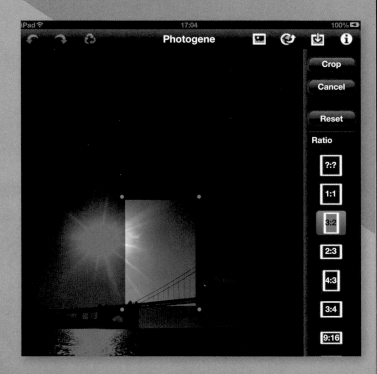

2 You can set a preset crop by tapping on one of the available ratios on the right of the interface from 1:1 to 16:9. The crop box on the screen will change to reflect your choice.

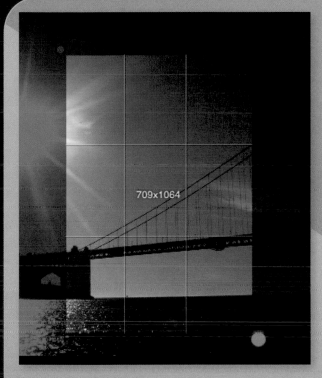

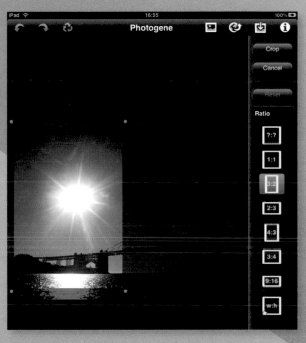

3 If you want to customize the size of your crop, drag one of the blue dots at the corner of the crop area to resize it.

4 You can move the entire crop area by tapping and holding within it, then dragging the crop zone to the required position.

5 When you are happy with your crop, tap the crop button at the top right of the interface to apply it. If you're not happy with the outcome, tap on the undo button at the top left.

Adjust exposure and color with Photogene

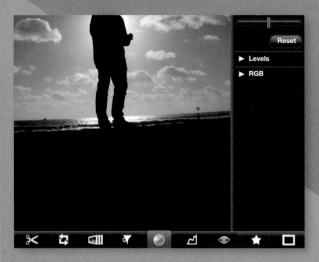

1 Click on the color wheel at the bottom of the interface to display the color, exposure, and contrast controls on the right.

2 Use the sliders to adjust each value and see the changes applied in real time to the image in the main window.

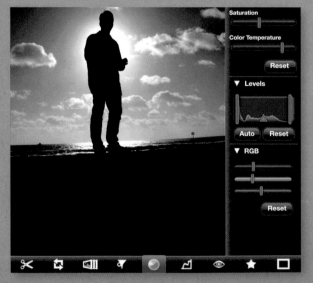

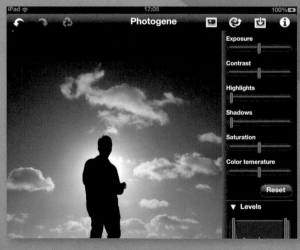

3 Click on the triangles next to Levels and RGB to reveal additional controls to adjust tone and color.

4 If at any time you want to return to the original color and exposure settings, hit the Reset button and Photogene will roll back any changes you have made.

Remove red-eye with Photogene

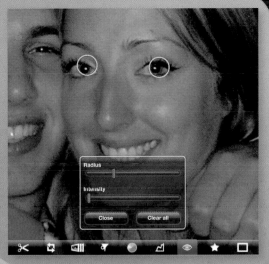

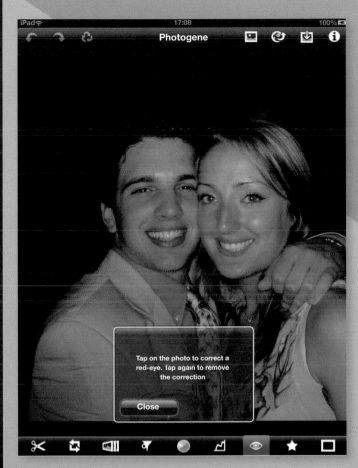

1 Load a photo with visible red-eye and then tap on the eye button at the bottom of the interface.

2 Zoom into the photo by pinching your fingers on the screen if required and then tap on the affected eyes to bring up two circles around them.

3 Drag the Intensity slider slowly to the right to begin removing the red-eye from your image.

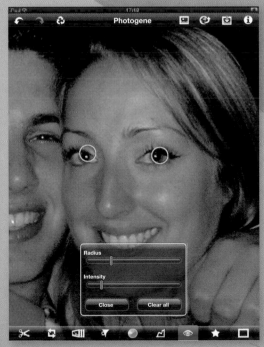

Remove red-eye with Photogene

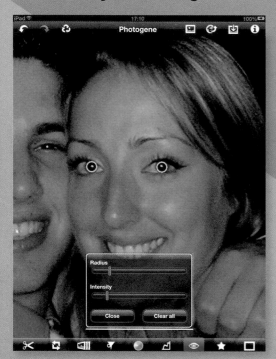

4 If you need more precise control you can adjust the size of the circles surrounding the red-eye by moving the Radius slider, then reposition the circles by tapping and dragging them.

5 When you're happy with your changes, tap Close to return to your image. All trace of red-eye should have disappeared.

Apply effects with Photogene

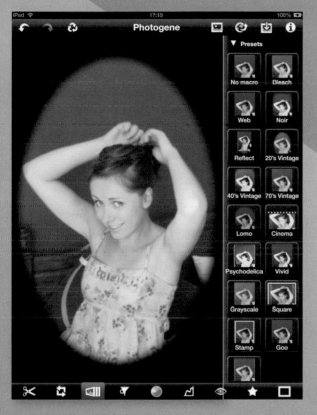

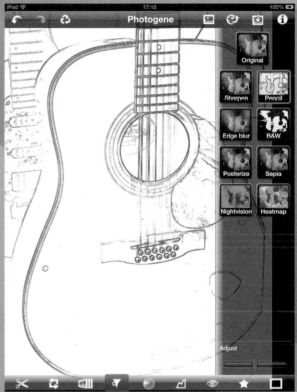

1 A variety of preset effects can be added to your image by tapping on the third button from the left. There is a wide selection available, ranging from Noir to Psychadelica, and you can also create your own using the Custom section at the bottom of the Presets list.

2 You can also add a range of simple filters to your image by tapping on the fourth button from the left. The selection includes posterization, sepia, and black-and-white filters, among other familiar favorites.

Apply effects with Photogene

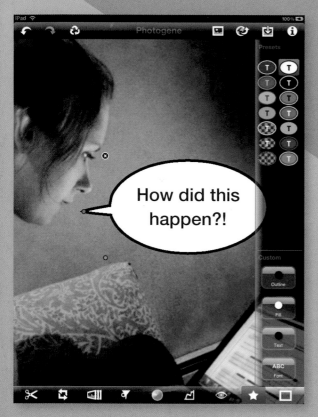

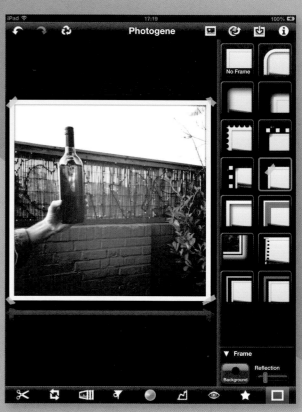

3 Fun shapes and speech bubbles can be added to your images using the star button at the bottom of the interface, and text can also be included by double-tapping on a shape.

4 The final button at the bottom of the Photogene interface provides a selection of photo frames, ranging from the clichéd to the relatively cool. These can be applied with a simple tap.

Save and share edited photos in Photogene

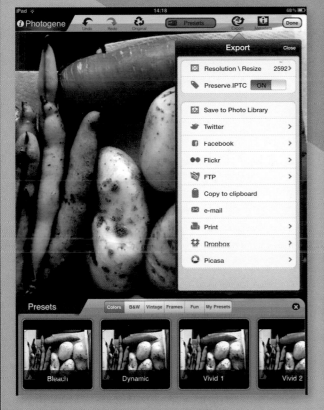

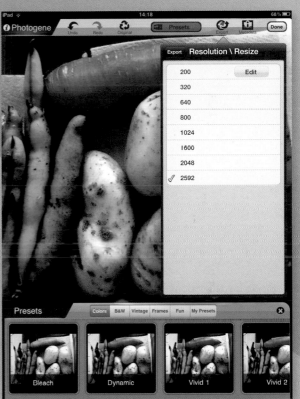

1 When you have finished editing an image with Photogene, you can save it to your iPad's Photo Library by tapping on the Export button at the top right of the interface, next to the Presets button

2 On the menu that appears, tap on the Resolution\Resize option and set the resolution you require. If you need to enter a custom resolution, tap the Edit button and enter the resolution into the field that appears.

3 The Export menu offers a range of locations to send your image to. Tap on the corresponding option to save or send your image. For Twitter and Facebook you will need to supply your account details. You can also copy the picture to the iPad's clipboard, send it in an email or print it.

Photoshop Express and photoshop.com

If you're already using Adobe's photoshop.com, then Photoshop Express for the iPad is its perfect partner. This popular online service allows users to share, edit, and host images for free, with up to 2GB of video and photo storage available with each account. Photoshop Express is the natural extension of the service on the iPad, allowing you to make use of all the features of the site using your iPad, and it also ties in with the Adobe apps on your desktop, providing another way to transfer and access your photos on the move.

The photoshop.com uploader tool makes it easy to add photos and video to your account, thanks to simple drag-and-drop functionality. You can even set albums to sync to your photoshop.com account so it's always up to date. Once you have your photos stored on pPhotoshop.com you can log in by using the Photoshop Express app and view, edit, and share your images right from your iPad. You can even upload shots from your iPad to photoshop.com, meaning edits made in the field can go live on the service within minutes. Using Photoshop Express on the iPad creates a unique workflow for your images and allows you to edit wherever you are, with the guarantee that any file you change on the move will be updated and ready for review the moment you get back to your desk.

Access photos from photoshop.com with Photoshop Express

1 If you haven't already, head over to photoshop. com and register for a free account. Use the web interface to upload any images you want to make available.

2 Launch Photoshop Express on your iPad and choose to allow or disallow the sending of anonymous usage data to Adobe from the menu that appears.

3 Tap the Online button at the bottom of the interface and enter your photoshop.com username and password to log in to your account.

4 Your library will now appear on the left of the interface. Tap on All Photos and Videos to show the available images.

5 Tap on an image thumbnail to load an image and swipe left and right to see more images in your library.

Edit iPad photos with Photoshop Express

1 Launch the Photoshop Express app and select Edit from the menu at the bottom of the interface.

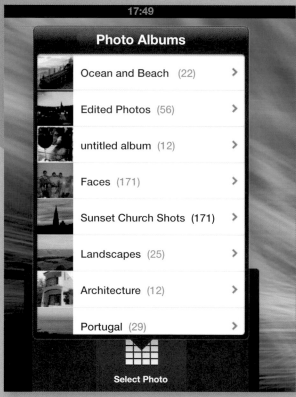

2 Tap on the Select Photo button in the middle of the screen and pick an image from your Photo Library or any imported albums on your iPad.

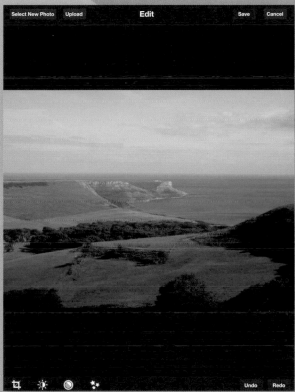

3 The image will now open within the editing interface with standard tools for cropping, rotation, and straightening, as well as color and exposure settings and effects.

4 When you're done editing your image, you can send it straight to your photoshop.com account by tapping first on the Upload button at the top of the screen, then on the photoshop.com button at the bottom. You can also upload images to Facebook if you wish.

SNAPSEED

Cool, fast, futuristic

Nik software have created something really exciting with Snapseed; rather than emulating the bars and sliders of Photoshop or its ilk, this has been designed as a touch app from the ground up, and as soon as you learn its very, very intuitive interface, you'll be able to quickly create exciting new looks for your images. Importantly, this isn't just a toy that uses the built-in camera; it is powerful, allowing you to exploit the extra bit-depth from Raw files saved on your camera, create rich and diverse images, and send them to friends (or clients) without needing a laptop. This really feels like the future.

Selected image adjustments exist in 'packs' (Nik sell extra features for Photoshop on Boxed CDs, hence the styling).

Swipe for more adjustments. Left to the basic, right for more creative.

All the usual tools are available, and you can always revert to the original with the one-click Revert button.

Applying a vintage look

1 Once you've copied your pictures from your camera onto your iPad, launch Snapseed and choose Open Image in the top left.

2 Slide the adjustments pane over to the right and choose "Vintage". As you do, the picture will leap to take fullscreen so you can get editing (a help page may appear too—tap to dismiss it and get to work).

3 With one finger, tap and drag up or down on the screen. A menu appears, and the option highlighted when you let go (repeated in the gauge at the bottom) is the one you can then edit. Then, simply stroke your finger to the right to increase the strength of the effect.

5 The center-point of your focus effect is indicated by a blue dot. With your finger, simply drag it to your picture's new focal point.

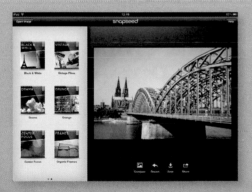

4 To accept the change and move on, tap the Apply button in the lower right, then choose Center Focus from the adjustments.

DESKTOP EDITING SOFTWARE

Working with desktop editing software and the iPad

The iPad works nicely with most of the major photo-editing and organization tools on both Mac and PC. Adobe's Lightroom and Apple's Aperture provide the cleanest ways to work between iPad and desktop when it comes to import and export, with both able to "see" the iPad and the photos it contains. As discussed in the chapter on importing photos, images from applications that do not automatically link to the iPad when it is connected to a computer can still be transferred back and forth using iTunes. If you are using Adobe's Creative Suite you can also import iPad images to Adobe Bridge through the Adobe Photo Downloader. This will make them available for use in any of the Creative Suite applications.

If you intend to edit the images you import from your iPad, it's best to remove them from the iPad after you've moved them to your computer, as otherwise you may get duplicates. Most applications that can import images from your iPad will also offer the option to delete the imported images after transfer. Once edited, these images can be transferred back to your iPad using iTunes in the normal way.

Extending your screen with Air Display

When you are working with photos on your desktop in applications like Photoshop, Light Room, or Aperture, your iPad can still be involved in the process. Using a number of third-party applications, you can add some real estate to your computer screen with your iPad by using it as an additional monitor. With the iPad docked next to your computer and an app like Air Display running, the screen of your iPad continues your desktop space and can be configured to appear on the left or right of the screen in landscape or portrait orientation. The connection between your iPad and computer is made through Wi-Fi, so you don't have to worry about additional cables. While the quality of display on your iPad when sharing screens isn't quite as good as the real thing, it still adds a handy bit of room for applications or folders that would otherwise clutter up your screen.

Even better, Air Display allows you to interact with items on the iPad screen using the touch interface, enabling you to move windows and control apps without having to move your cursor to the second screen. For photographers, this method offers some serious benefit, especially when using applications with tool palettes like Photoshop. By grouping all of your palettes onto the iPad screen you can use all of your desktop space to work on an image, tapping the required tools as you need them. Air Display will also dramatically improve the screen area of a laptop, in some cases doubling it, when the iPad is used as a second display.

Extend your computer's screen with Air Display and an iPad

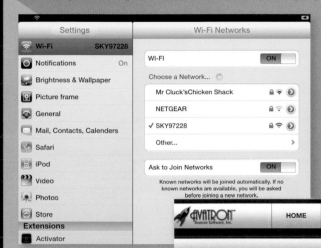

1 Make sure your iPad and computer both have Wi-Fi turned on and are connected to the same wireless network.

2 Download and install the Air Display support software from www.Avatron.com/ad, then launch it to configure your system.

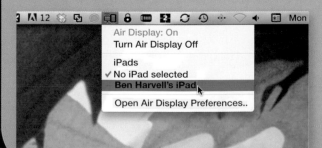

3 Launch Air Display on your iPad and click the Air Display icon on the menu bar. Now select your iPad from the pull-down menu. If required, open System Preferences and adjust your display settings to fit your iPad into the configuration.

SHOOTING AIDS

As well as the obvious benefits the iPad provides when it comes to viewing, sharing, and editing images, it also offers a wealth of useful features when shooting. For a start, the iPad is a very portable device that can easily be slung into a camera bag without adding as much weight as a laptop to your already heavy selection of kit. Second, as it's pretty much all screen, the iPad makes an ideal preview tool when using it tethered to your camera. In fact, with

a 1024 x 768 display and 4:3 aspect ratio, images will be displayed more accurately than on some laptop screens. Then there's the rest of the iPad's built-in features to consider, the organizational powers of the Calendar app, plus email access and Maps.

...a wealth of useful features...

With a web connection, not only does the iPad provide a unique way to get instant feedback on the images you take, it also enables you to share them and stay on top of the admin at the same time. There are many great applications available on the App Store that will be perfect for your organizational requirements, but for the duration of this chapter, the focus is mainly on the apps you already have. Some features do require a web connection, so if you're not using a 3G iPad or a mobile hotspot, you may not be able to make use of all of them. However, if you also have an iPhone, it can fill in for your iPad when you're away from a Wi-Fi connection. Later in the book, we'll look at some examples of ideal applications that will add even more features to your iPad, but for now let's take a look at the ways in which you can organize, plan, and even geotag your photos.

Mail

Thursday
16

Calendar

Maps

RIGHT As well as performing as a photography tool, the iPad can also serve as a perfect digital organizer. This is ideal for photographers looking to keep track of shoots, deadlines, and other events.

SHOOTING AIDS

Planning and workflow

With a suite of organizational tools coming as standard with the iPad, you won't be short of ways to stay on top of your day-to-day tasks. The main contenders here are the email, calendar, and map tools, which all work beautifully together to help your workflow run smoothly. For an inexpensive and effective way to keep all of your information in sync, try using Google's family of tools, which includes a calendar and email, plus online office applications. These apps and services are available for free, and you can sign up for them via www.google.com. What's more, Google's services are compatible with all the iPad's corresponding apps; a Google Mail™ account can be synced with the Mail app, while contacts from your Google account can be synced with the Contacts app. Google's online Calendar can be synced with the Calendar app and the iPad's Maps app is actually powered by the Google Maps™ service. Even Notes can be synced to multiple accounts if you wish.

You can access all of these services directly from the Google website, but by adding the accounts to your iPad you can keep all your vital information in sync from wherever you are. The same services work with apps on your computer, further extending their usefulness.

ABOVE The iPad's built-in Notes application is perfect for jotting down information when you're shooting in the field.

Working with email, your calendar, and the Maps app

Let's say a client has commissioned you to perform a shoot at a location you've never visited before. You need to find where you're supposed to be going, keep in touch with the team you're working with, and cost the shoot as you go. The date is in your iPad's calendar, be it Google or Yahoo!, and the appointment can be shared with all of those involved. You take your iPad with you so you can use the Maps application to quickly locate where you're headed and even get directions. If you're meeting others at the shoot, perhaps models or assistants, you can then email the exact location to them from the Maps application, and they will then be able to view this through Google Maps on any web-connected device they use. With the Notes app you can quickly check off a list of "to do" items both before and during the shoot, and share this list by way of email.

There are also a number of third-party "to do" list apps on the App Store that offer a more detailed set of features for organizing just such an event. During the shoot you can keep others informed of your progress, track new locations, store the coordinates by way of the Maps app, record light readings and timing information, and even use Apple's Numbers or a Google Documents™ spreadsheet to add last-minute expenses to your budget. Whether you use the iPad's default tools or buy others from the App Store (find out which are essential in the chapter on must-have apps), the iPad offers all the flexibility of a laptop, and more, without the additional bulk. Even without a web connection, the iPad is perfectly capable of storing the information you enter into it offline, ready to be shared when you next have Internet access.

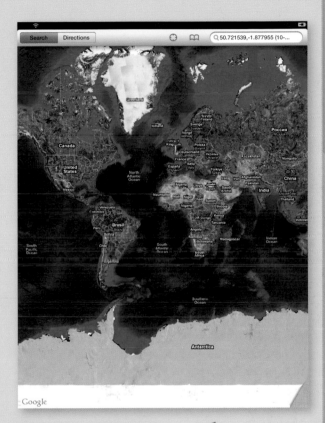

ABOVE The Maps application offers a handy way to plan your route and allows you to use GPS coordinates.

©2010 Google—Map data ©2011 Maplink, Tele Atlas, Imagery ©2011 NASA, Terrametrics

TETHERED SHOOTING

It's not a well-known fact, but the iPad can also be used as a display for tethered shooting. It's a little more fiddly than the traditional method of connecting a camera to a laptop or desktop computer but, once you have it configured, it's a great way to show pictures to others as they are being taken. In fact, you can even use the iPad to trigger the shot if you want. Both of the methods described below require additional software and will also need a laptop or desktop computer to work, so it's not true iPad tethering, but it's still a neat trick nonetheless. Hopefully, an app will provide support for true tethering in the near future, but for now the best options are to use Air Display HD as an external monitor and control, or use an Eye-Fi card and Apple's Camera Connection Kit with the ShutterSnitch App.

Tethered shooting using Air Display

This method is probably the simplest of the two to set up, but will require you to already be using tethering software on your computer or laptop. When testing this setup, I found Adobe's Lightroom to be the best tool for the tethering job, but feel free to experiment with your preferred software. First up, you'll need a copy of Air Display from Avatron Software, the same app mentioned in the section on desktop editing earlier in the book. You will also need compatible tethering software such as Adobe's Light Room (or any tethering app that came with your camera) running while you take your shots, as well as the free desktop components for the Air Display software.

Effectively what is happening using this technique is that the tethering application on your computer is displayed on the iPad's screen wirelessly. The image quality isn't incredible, but it does allow you to view the shot you've just taken and even trigger the camera using the iPad's interface. The technique still requires a computer or laptop, but it does add an additional screen into the mix, meaning you can have your laptop or desktop computer working as your preview and give the iPad to someone else to monitor shots wirelessly from anywhere within range of your Wi-Fi network.

1 Launch Air Display on your iPad and your computer.

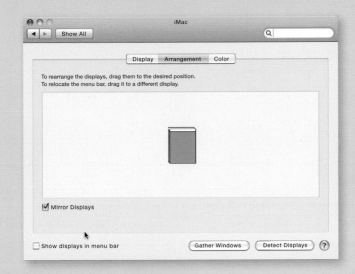

2 Set the desktop application to Mirror Displays so you see the same on your computer screen as you do on your iPad.

3 Launch your chosen tethering application and bring it up to full screen. Configure the application so that it's ready to be tethered to your camera.

4 Connect your camera to your computer as usual and position it ready for shooting with a tripod. Shoot your images manually or using on-screen tools using the iPad or your laptop. While you are shooting you can mount your iPad or give it to others to view the shots as they are taken.

TETHERED SHOOTING

Tethered shooting using an Eye-Fi card

Another way to capture images from a camera using your iPad is by using a wireless memory card called an Eye-Fi. This card can connect by way of Wi-Fi to a computer or, in this case, an iPad, and transfer the images stored on it. By using an application called ShutterSnitch, the iPad can show the images stored to the card on its screen each time a picture is taken, making it ideal for setting up shots or for showing work in progress to models and clients while you shoot. In order to make this technique work you will need a camera that is compatible with the Eye-Fi card, a copy of the ShutterSnitch app, and a wireless network to connect to. You could create an *ad hoc* wireless network using a mobile Wi-Fi router, but this is ideally a technique for a studio where an existing wireless network is in place.

Geotagging

Geotagging, or the process of adding GPS coordinates to the metadata of an image, is becoming increasingly popular. It makes sense for photographers to make use of the technology to organize galleries and record favorite shooting locations. A number of popular cameras from major manufacturers come with a built-in GPS chip that records location data for each photo, and there are also a number of devices that can be carried on the photographer's person, or attached to a DSLR, that perform the same task. If you have an iPhone 3G or above, you can even download an application to record GPS locations while you shoot. Most non-built-in options require additional software to match coordinates to photos after shooting and this normally comes bundled with the devices themselves.

Geotagging is especially important to iPad users as it means that they can make use of the Places feature found in the Photos app to sort their images by location. Within the Photos app, tapping on the Places button at the top of the display shows a world map with thumbtacks placed at locations where photos have been taken. The app uses the metadata included in geotagged photos to position them on the map, and this provides a handy way to sort your images by country or place. The iPhone and iPad 2 camera records GPS data with each image taken, which can come in handy on shoots or location scouting. Simply snap a quick reference shot and your location will be logged. As an alternative to the above methods, if you don't have an iPad 2 or an iPhone, you can also use your iPad to record basic GPS information while you're shooting by using the Maps application to find your current location. You can then send the information in an email to yourself or your colleagues so that you can add it to the metadata of photos for organizing later.

Geotag

LEFT An Eye-Fi card can connect via Wi-Fi to your iPad.

Store your GPS location using an iPad

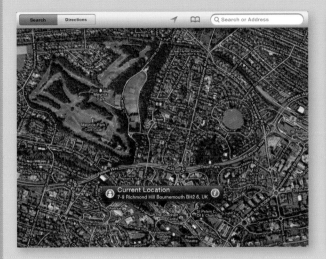

1 Start by launching the Maps application from your iPad's home screen. Now tap on the arrow button at the top of the interface to pinpoint your current location.

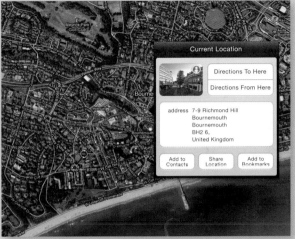

2 A small blue dot will appear on the map with a red thumbtack. Tap on the dot and then tap on the blue 'I' button that appears next to it.

3 Now tap on Share Location in the box that appears to send the location in an email. Add your own address in the To: field and tap on send.

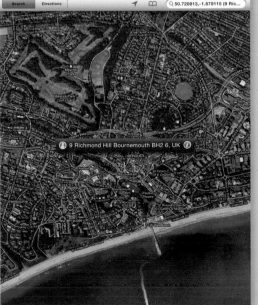

4 When your email arrives, the first line will include a link that, when clicked, will open in Google Maps on a computer and in the Maps application on the iPad. The GPS location will be included in the search field.

BENEFITS OF THE iPAD 2 CAMERAS

Benefits of the iPad 2 cameras

The front- and rear-facing cameras in the iPad 2 are by no means of professional quality, and aren't even at the same level as the camera in the iPhone 4. They can, however, prove useful for snapping a reference shot to quickly send via email, or store for geotagging purposes, as we mentioned earlier. You also have the option to record video which can help to sum up a potential location better than a group of photos from the iPad's camera. Shooting is as simple as tapping the Camera icon on your iPad's home screen and pointing your device. You can opt to switch between cameras within the Camera app and also switch between video and still modes using the slider at the bottom of the screen. Another benefit of built-in cameras in the iPad 2 is the FaceTime feature that enables video chat between compatible devices such as iPhones, iPod touches, Macs, and other iPads. You will need Wi-Fi to use FaceTime, but a MiFi device will work when you're on location and away from your home or office connection. Using video calling can add a greater level of communication to your work and can show off locations to others, almost as if they were there. Finally, on the iPad 2 camera front, there's the Photo Booth app which, more than anything, is a bit of fun. The chances are, you could use it to good effect (excuse the pun) for some more novelty work, but it's more likely to end up as a tool for distracting kids on shoots rather than providing any real worth.

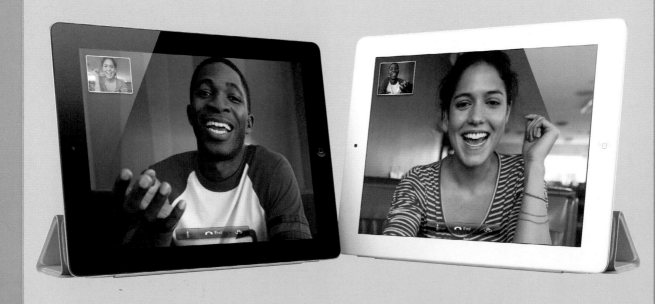

Shoot with the iPad 2

1 Launch the Camera app on your iPad and move the slider at the bottom right of the screen to the camera position if it's not there already.

2 Aim your iPad's camera at your subject and tap on the focal point on-screen in order to set an automatic focus and white balance.

3 When you are ready to take your shot, press the camera button at the bottom of the interface. Your image will now be stored in the iPad's Camera Roll.

4 If you want to use the front-facing camera on the iPad, tap the button at the top right of the interface to switch cameras. You should now be able to see yourself and can take a picture in the same way as step 3.

Add fun effects to shots with Photo Booth

1 Launch the Photo Booth app and tap on one of the preset effects that are displayed. If required, tap the camera button at the bottom right of the interface to switch to the main camera and not the front-facing option.

2 For most effects you can slide a finger across the display to change the position of the manipulation and adjust the effect. When you're happy, tap on the camera button at the bottom of the interface to take your shot. Your image will now be sent to the iPad's Camera Roll.

REMOTE SHOOTING

This is one for the true Apple devotee in that it requires two devices based on the iOS operating system, meaning an iPad, plus an iPhone or iPod Touch. Both devices need a copy of Camera for iPad, but you'll only need to pay for the app once as it's universal and will work on iPhone, iPod Touch, and iPad. The two apps then communicate either over Wi-Fi, if both are connected to the same network, or Bluetooth. The application allows you to not only shoot the picture remotely, but to immediately transfer it to the other device. There is also a "flash" feature, which is admittedly of limited use. It sets the iPad's screen to bright white (or a color of your choice) at the moment of shooting so that, if it's positioned nearby, it can provide extra light to your subject. While the camera in the iPhone isn't exactly a professional tool, the one used in the iPhone 4 provides better image quality over the original and would be perfectly acceptable for use while scouting locations if you don't have your camera handy. The Camera app for iPad and iPhone is relatively inexpensive, so some experimentation won't break the bank.

1 Launch the Camera for iPad application on your iPad, then launch the same app on your iPhone. You may see a message asking you to switch on Bluetooth, but this is not necessary if you are on a Wi-Fi network. Wait a few moments and the devices will find each other on the network, and you'll get smoother updates of your iPhone's current view.

2 Once connected you will see what your iPhone camera can see on both devices. Position your iPhone in the location you want to take a photo from, checking the iPad screen if necessary.

3 You can rotate the camera view on the iPad screen with a single-fingered rotary gesture to reflect the phone's orientation. You can also zoom in and out using the pinch gesture.

4 When you're ready, press the Take Photo button on the iPad to shoot your picture. Once you've finished, quit the app on both devices and return them to their respective home screens, as broadcasting images can be a battery-sapping process.

SHARING PHOTOS

Of all the iPad's skills, its most important is the way in which it displays photos. Why carry around a printed portfolio, when the iPad provides the photographer with access to a huge number of images and galleries that potential clients can interact with and enjoy using its impressive display? With up to 64GB of storage available, more images can be carried on the iPad than in a backbreaking number of physical albums, and the touch interface offers a far more intimate experience than viewing photos on a laptop or via a projector. The iPad offers a variety of ways to display images too, from simple image-by-image views that can be worked through by dragging a finger across the screen, to beautiful slideshows. Existing portfolios aren't ignored by the iPad either. It doesn't matter where you store your photographs online: you can access them on the iPad, whether they're part of a Flickr gallery or on your own website.

...enjoy using its impressive display...

...a far more intimate experience...

:DISPLAYING PHOTOS

Displaying photos on the iPad

The central source for images on your iPad is the Photos app, which offers a number of ways to view your images and helps to organize the photos in your library by date, location, and the people in them. The Photos app also provides the facility to create slideshows in a number of different styles as well as copy and email your pictures. When it comes to showing your images to clients, friends or family, this is the app you should go to. Every photo you've synced to your iPad or saved from the web or email is stored here and you can quickly interact with individual shots by swiping across them or pinching to zoom in and out. When showing a picture, the iPad is always aware of its positioning, so the photo will appear the right way up not just when you look at it, but when you flip the device over to let others have a look as well.

LEFT The iPad Photos app offers a number of useful ways to view your photos, while its intuitive design makes interacting with them a breeze.

:DISPLAYING PHOTOS

Photos

The iPad's default photo viewer is as simple as it gets, yet it's still a very effective way to show off photos. By selecting the Photos button at the top of the display, all of your images are shown as thumbnails which, when tapped, are displayed full screen. You can move back and forth between images with a swipe of your finger and zoom in and out by pinching two fingers on the screen. When a full-screen image is tapped on, a small bar appears at the bottom of the screen showing a preview of all the images on your iPad. You can run your finger along this display to quickly jump to a specific image in your collection. Should you have an Apple TV connected to your network, you can use the AirPlay button at the top of the screen to send your images to an HDTV.

Albums

The Albums view shows every album you have stored on your iPad and groups images into these collections. Tapping on an album will show all the images within it, but you can also pinch on a gallery name to peek inside it. The reverse is true once a gallery is open; by drawing your fingers together you can close the album and move back to the Albums view. Inside an album you can tap on images to view them full screen in the same way as the Photos view, and scroll up and down through the available images by sliding a finger up or down the screen.

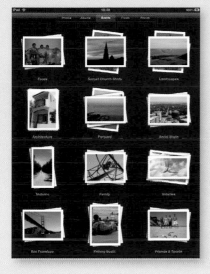

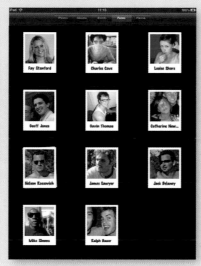

©2010 Google—Map data ©2011 Geocentre Consulting, Maplink, Tele Atlas

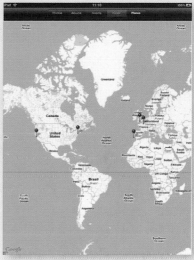

Events

If you are using iPhoto or Aperture you can choose to organize your photos by Events. Events take the time and date from an image's metadata and group photos from the same day into an album. When you tap on the Events button at the top of the Photos app you will be shown a screen of all the available Events on your iPad. Tap on an Event to see the photos within it or pinch it open with two fingers to preview what's inside.

Faces

Faces is another iPhoto and Aperture-only feature that recognizes faces in your photos and groups them into albums of the same person. The actual recognition is done on the computer, and the photos are then tagged for use by the iPad. When you tap on the Faces button at the top of the Photos interface you will be presented with small polaroids and a representative picture of each person included in your collection of faces.

Places

If your images have been geotagged they can be displayed in the Places view on your iPad. Powered by Google, each different shooting location appears on the map as a red thumbtack which, when tapped, displays all photos taken at that spot. You can change the map view as you wish by pinching to zoom in and out, while you can also preview the images taken at a location by pinching on the image preview.

:SLIDESHOWS

iPad photo slideshows

You can create slideshows for the iPad in a matter of seconds and still produce some attractive results. The option to include music and a variety of transitions adds to the effect and, should you have the requisite equipment, you can even send your slideshow to a larger display or projector when sharing photos with a larger audience. A slideshow can be created using all the photos on your iPad or pulled from a selected event or album. You can also select music from any song, playlist, or artist stored on your iPad as backing. In order to display the slideshow on a larger screen and the audio through speakers, you will need to have access to Apple's iPad Dock Connector to VGA Adapter or HDMI adapter, as well as a spare cable to run from the adapter to your display and an audio cable to run to your speakers should you be using the VGA option. Once connected to a TV, projector, or LCD computer screen, slideshows from the Photos app will be displayed on the screen. Audio can be output from the iPad's headphone socket via a mini-jack cable with a compatible connection at the other end for your TV or hi-fi system. Portable speakers will, in most cases, only require a mini-jack to mini-jack cable, which may be included or is readily available for little cost from most electronics stores. Slideshows can also be sent to an Apple TV connected to an HDTV using Apple's AirPlay technology to wirelessly stream the images. If you have the compatible kit and your iPad and Apple TV are on the same network, you can simply hit the AirPlay button on your iPad slideshow and select your TV from the pull-down menu.

Create a slideshow

1 Start by launching the Photos app from your iPad's home screen and selecting an Album, Event or all of your photos.

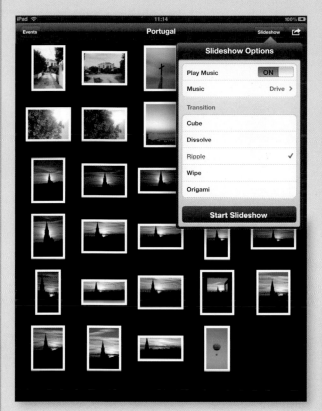

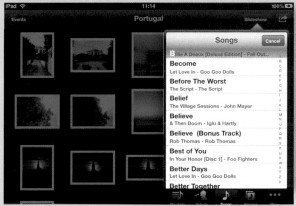

3 Select a music track from your iPad's music library by tapping on the Music section and selecting something from the list of available tracks.

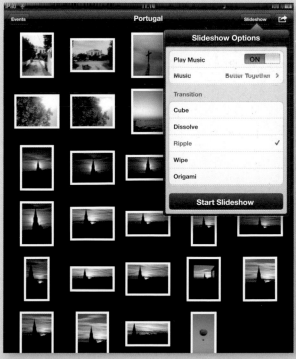

2 Now press the Slideshow button at the top of the interface to reveal the slideshow menu. Opt to turn music on by moving the slider to the On position.

4 You can pick a transition from the list of available options just by tapping on its name. A check mark appears next to it. Start the slideshow by tapping the Start Slideshow button, and, if sharing the slideshow to a larger screen, make sure the VGA adapter is connected to your iPad and to the display.

SHARING A SLIDESHOW WITH AirPlay

If you're using Apple's iPad dock, you can give your office or meeting room a professional feel by showing off your portfolio while your iPad sleeps. When the iPad is locked and the Slide To Unlock slider is displayed, you can tap the Picture Frame button to launch a photo slideshow as a kind of screensaver that will display a selection of photos you choose. An added feature over the Slideshows in the Photos app is the ability to zoom in on faces found in photos as the images are loaded—ideal if you work with portraits or want to show off pictures of a specific person. The Picture Frame mode works perfectly when the iPad is sitting in its dock or held upright with a case. Leave it standing on your desk and you can show off your skills before you even begin your pitch.

1 First make sure your iPad and Apple TV are on and connected to your wireless network. Now set up your slideshow in the normal way.

2 With your slideshow ready, tap on the AirPlay button which should appear at the top right of the screen. Select your Apple TV from the list.

3 Tap on the Slideshow button and then tap on Start Slideshow to begin playing it on your Apple TV.

4 With your Apple TV selected on the AirPlay menu you can also flick through individual images which will be shown on your Apple TV.

A PICTURE FRAME

Use your iPad as a picture frame

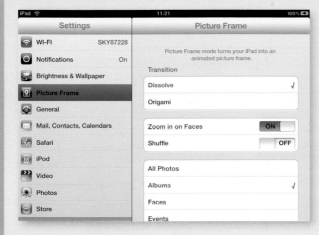

1 Head to the Settings app from your iPad's home screen and tap on the Picture Frame option.

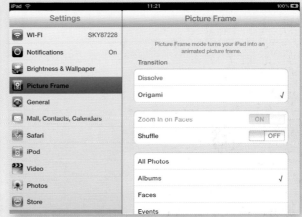

2 Set the transition you wish to use to anything from Dissolve to Origami by tapping on one of the options at the top of the screen.

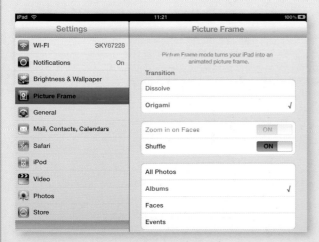

3 Set Zoom in on Faces and Shuffle on or off to determine whether the iPad focuses on any faces it finds in your images and if it follows a linear order or mixes up your photos as they are displayed.

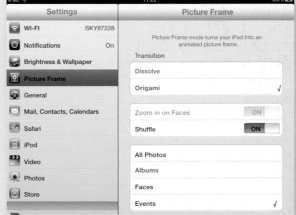

4 Select which photos you want displayed within the Picture Frame slideshow by tapping either All Photos (to display every picture on your iPad), or Albums, Faces, or Events to select images from a specific collection.

:A PICTURE FRAME

Use your iPad as a Picture Frame

5 You can also choose which library the Picture Frame selects images from by selecting Saved Photos or Photo Library.

6 To launch your Picture Frame slideshow, lock the iPad using the Sleep/Wake button and then press the Home button to display the lock screen. Now click on the Picture Frame button next to the slider.

EMAILING PHOTOS

Sharing photos through email

One of the quickest ways to get your pictures to others is by sending them in an email. While there is a limit on the size of the email you send, you can normally fit a few snaps into a message and send them relatively quickly. It appears that the iPad automatically limits the email sharing to around five images so you may have to send your images across a number of emails if you want to share more. The process is best performed using a Wi-Fi network rather than 3G to improve transfer speed and reduce data use but either connection method will work fine. Images can be sent directly from your iPad's Photos app or copied and pasted into a new email message on the iPad.

Email photos from an iPad

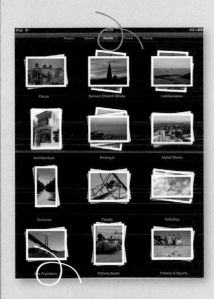

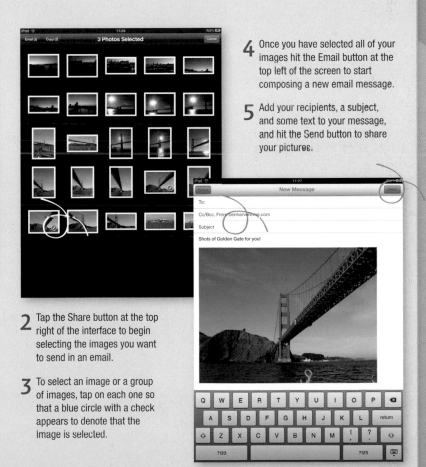

4 Once you have selected all of your images hit the Email button at the top left of the screen to start composing a new email message.

5 Add your recipients, a subject, and some text to your message, and hit the Send button to share your pictures.

1 Start by launching the Photos app and viewing the Album or Event you want to pick images from. Alternatively, just show all the photos on your iPad.

2 Tap the Share button at the top right of the interface to begin selecting the images you want to send in an email.

3 To select an image or a group of images, tap on each one so that a blue circle with a check appears to denote that the image is selected.

SHARING TOOLS

Printing from an iPad

For a while now, both the iPhone and iPad have included a feature called AirPrint that allows you to print directly from your iPad to a compatible wireless printer. This is by far the easiest way to print images from your iPad, and, if you have the right kit, is the best option. Should you not have a wireless printer, or for some reason don't want to update your iPad software, it is possible to export images from the iPad and onto a computer ready for printing. Should you wish to print directly from the iPad, Air Sharing HD, which we covered in chapter two, also provides a wireless printing option for Mac computers that will allow you to send images to a printer on your local network. This option may come in handy when you don't have a laptop or desktop computer with you but can connect to a Wi-Fi network that includes a shared printer, whether in an Internet café or as a guest on a friend's or client's network.

...it is possible to export images from the iPad and onto a computer ready for printing...

Printing wirelessly

There are a number of apps that offer wireless printing from an iPad and some are geared to specific printers. However, Air Sharing HD allows you to connect to all your available printers and doesn't require additional software installed on your computer to do so. Air Sharing HD simply searches the available wireless network for printers and sends your image to it. Air Sharing HD can also print PDFs and other compatible documents if you need it to. At the moment, the app only supports printing for Mac computers, but there are alternatives available including ActivePrint, which provides printing over any available network when connected to a PC running compatible software. All you need for either of these apps to work is a wireless network for the iPad and computer to connect to and a printer connected to your computer. Besides a little initial setup to configure the sharing of information between iPad, computer, and printer, all should be relatively simple.

Air Sharing HD

PRINTING WITH AIR SHARING HD

Print a photo from your iPad with Air Sharing HD

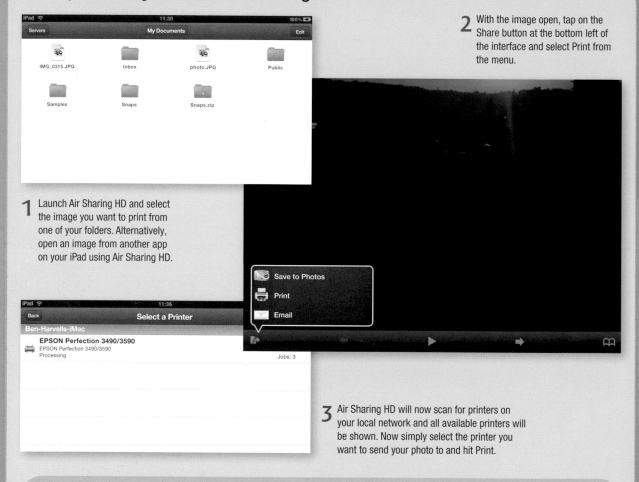

2 With the image open, tap on the Share button at the bottom left of the interface and select Print from the menu.

1 Launch Air Sharing HD and select the image you want to print from one of your folders. Alternatively, open an image from another app on your iPad using Air Sharing HD.

3 Air Sharing HD will now scan for printers on your local network and all available printers will be shown. Now simply select the printer you want to send your photo to and hit Print.

Print photos with AirPrint

1 Start by making sure your printer is switched on and connected to the same network as your iPad.

2 Now locate the image or document you want to print from your iPad's Camera Roll or Photo Library. This also includes emails and other compatible applications.

3 Tap on the Share button and select Print from the menu that appears. Your iPad will now list available printers and you can select which to use by tapping next to the word Printer on the Printer Options menu.

4 Select the number of copies you would like to print and tap on the Print button to send your image to the printer.

PRINTING WITH ACTIVEPRINT

Print a photo from your iPad with ActivePrint

1 Start by downloading the ActivePrint Desktop software from iphone.activeprint.net, and set it up according to the instructions provided.

2 Now launch the ActivePrint app on your iPad and pick an image from your photo library to print.

3 Position the image as you wish on the screen and then tap the Print button.

4 On the next screen enter your system address details and port number from the desktop software if you haven't already and give your document a name. Finally, tap on Send Print Job to print your image from your computer.

PORTFOLIO TO GO FOR FLICKR

Using Portfolio To Go for Flickr

Portfolio To Go is the perfect app for artists and photographers who use flickr.com to showcase their photographs online. Its elegant and intuitive Photo Wall gives users instant access to all of their Flickr photosets: you scroll each gallery horizontally to browse through the thumbnails, or scroll vertically to traverse through all the synced galleries. The main purpose of Portfolio To Go is to enable photographers to present their portfolio offline to clients. It's perfect for use with iPad Wi-Fi—just sync and go. Create and edit your photosets on flickr.com and Portfolio To Go will act as a presentation tool, keeping in sync with all your Flickr changes.

Portfolio To Go supports all iPad rotations, meaning it can be flipped vertically for portraits and horizontally for landscapes. Another unique selling point of this app is the "Send Portfolio to a Client" feature. The user carefully selects which of their galleries to share and can then send an auto-generated email to clients and friends containing a free download link to the "Portfolio To Go Player" iPad App. By clicking the emailed link, clients can launch and review the photographer's portfolio on their own iPad.

Sync and share your portfolio with Portfolio To Go for Flickr

1 When Portfolio to Go first launches it displays a Flickr login screen and then requests access to your Flickr account. It requests read-only access to download and cache both your public and private photos and photosets.

2 After logging into Flickr, Portfolio To Go starts downloading your Flickr photosets and creates local, synchronized, cached galleries on your iPad.

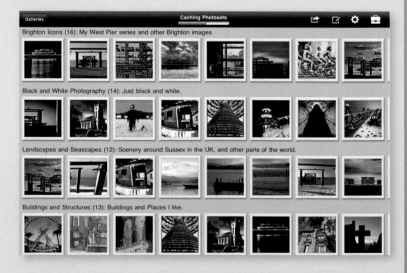

Portfolio To Go
For Flickr

3 Once your Flickr photosets have been created locally, Portfolio To Go automatically loops through all of your Flickr photos, downloading and caching each photo in turn. The speed of this process is dependent on the size of your Flickr photos and their quantity, but you can check the caching status by pressing the spinning activity indicator. Once this process completes you'll be able to demo your portfolio offline.

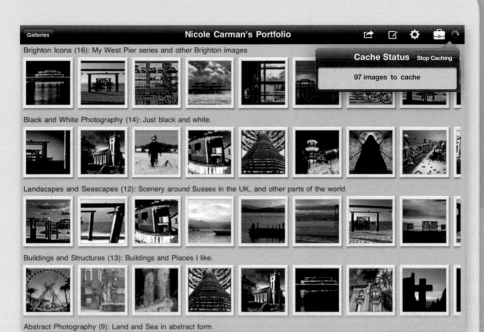

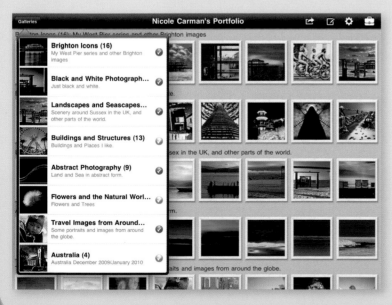

4 Each gallery can be scrolled horizontally and the whole Photo Wall scrolls vertically through your Flickr photosets. Galleries can be switched on and off through the Galleries button on the Photo Wall.

PORTFOLIO TO GO FOR FLICKR

Sync and share your portfolio with Portfolio To Go for Flickr

5 Touching any thumbnail will trigger the app to transition from the photo wall into a touch-responsive slideshow of the chosen gallery. Tapping the main image in slideshow mode makes the image go full screen.

6 Portfolio To Go enables you to send your selected Flickr photosets to clients and friends by email. Before using this feature, first select the galleries you do/don't wish to share (as in step 4). Next, use the settings pop-up to select the best image scaling option for your photos. Via the action menu you'll find the first option "Send Portfolio to a Client" will automatically generate an email with a link to your portfolio. The generated email contains instructions of two simple steps for clients and friends to follow to view your portfolio through a free iPad app called "Portfolio To Go Player."

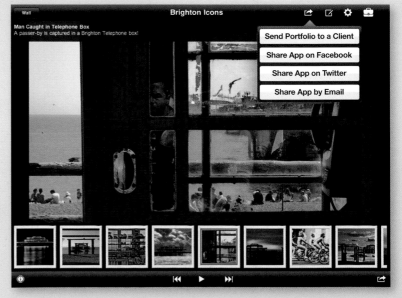

ABOVE The old MobileMe Control Panel. From left to right, showing Mail, Contacts, Calendar, Galleries, iDisk, and Find My iPhone.

From MobileMe to iCloud

If you are a subscriber to Apple's MobileMe, then you'll probably know that it's being phased out in 2012. Your email service will still be accessible via the new address www.icloud.com. iCloud will also be the new home of your online contact and calendar syncing service, with features like Contacts syncing with a desktop computer, iPad, or iPhone. This, like MobileMe, is updated using "push technology" so that new information is reflected instantly across all platforms. For those already using MobileMe, you can continue using your Gallery until the 30th of June 2012, even after moving to iCloud.

Creating a MobileMe Gallery in iPhoto or Aperture is as simple as creating a new album and dragging photos into it. These can then be sent to Facebook, Flickr, or a MobileMe Gallery. Those not using a Mac can still make use of the feature by using the online interface at me.com, but won't be able to sync images from the desktop quite so easily.

Gallery features

As you can see, the Gallery as it existed in MobileMe has been removed. You can use the Photostream for the most recent 1000 pictures, but for something more like the Galleries, you may need to wait and see—log onto www.web-linked.com/ipad for the latest updates.

BELOW The new iCloud service screen looks similar to MobileMe, but new tools can be added here by developers.

RIGHT The icon to return to the main iCloud page is in the top-left of each section (the Mail service, for example).

VIEWABLE WEB PORTFOLIO

How to make your web portfolio viewable on the web

If you sit down with a client, do you want to pull out a laptop, a heavy and possibly ragged photo album, or a cutting-edge slice of portable technology? As we discussed earlier in the book, the iPad makes a great first impression to clients, whether you're checking your email and updating your calendar, or showing them your portfolio. Your website does the same job and it's likely that, during the course of your meeting, you'll refer potential clients to it. In this scenario, depending on the design of your site, the iPad might fall down.

...the iPad makes a great first impression to clients...

As this chapter will explain, there are certain elements of a website, if not the entire site, that won't display in the iPad's Safari browser. Showing a website full of holes where your galleries should be is not the first impression you're after. It's also worth considering that, with astronomic iPad sales worldwide, prospective clients may use their own iPads to view your site. The reasons for this problem as well as a selection of solutions are coming up but, be warned, they come with their costs, both in terms of time and money. I've tried to balance the options for every budget but prepare yourself to spend a weekend tweaking your web presence if you want to remain truly compatible.

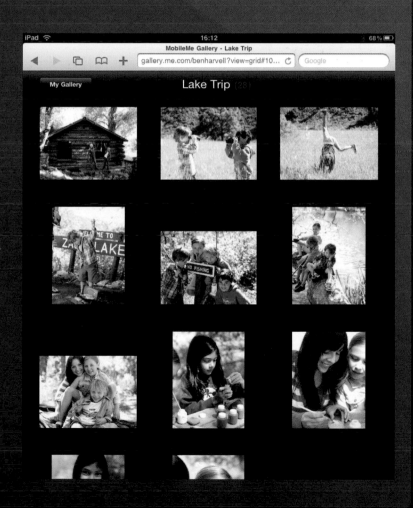

RIGHT A gallery is a guaranteed way to make sure your online images are compatible with iPhones and iPads.

FLASH ON THE iPAD

Flash and its lack of support on the iPad

One of the most complained-about iPad foibles is that it doesn't support Adobe Flash. If you don't know what Flash is, the chances are you should if you want your website to look good or even work at all on an iPad. Flash is a software language used to create anything from an entire website to games and web-based video players such as those you would find on YouTube.

It's not an accident that Flash won't work on an iPad either; it's a conscious decision made by Apple, who sees the technology as dated and full of bugs. Instead, Apple prefers the HTML5 standard. This may one day render Flash obsolete, but at the moment it's still in its infancy, hence a lack of widespread use. If you happen to browse to a web page that includes Flash content you will either be met with a message telling you to download the latest Flash software (which is impossible on an iPad) or even worse, an ugly blue block indicating the lack of Flash support.

As the popularity of the iPad continues to grow along with the iPhone and iPod touch (which also don't support Flash), most web designers and media outlets are catching on, providing their advertising, sites and video content in HTML5. But what about your site? If you have a self-made or professionally designed site made in the last five to ten years, the chances are it's filled with Flash elements, especially for the snazzy transitions and photo-zooming effects. In the worst case scenario, your site could have been built entirely in Flash making it completely useless on an iPad. So what do you do if this is the case? Fear not, there are options available.

Working around Flash

Whether you want to start again from scratch or employ a cheeky work-around, it's ultimately worth it. Not only will your site become instantly compatible with almost all modern mobile devices, you'll also be able to take your website with you wherever you go and show clients your pictures in a much more personal way. You ultimately have to ask yourself, will someone who visits your site on an iPad and sees nothing bother to launch their desktop browser to take a proper look? Take this step out of the equation and boost your compatibility and client roster in one move. And if, after all the options in this chapter, you feel like you may as well just start again from scratch, check out the information on Squarespace at the end of this chapter and later in the book.

Flash

BELOW Adobe and Apple have their differences when it comes to Flash and the iPad, but HTML5 is gaining popularity as an alternative.

The redirection method

Rather than have to go through the expense of completely redesigning your site or forking out for someone else to do it for you, consider this slightly fiddly method to send iPad users to a separate site that will be viewable on their device. If you make your own website using commercial software it's likely you know a little about HTML code and Java script. If not, and if you're using WYSIWYG (What You See Is What You Get) website design tools, bear with me—it's really not as terrifying as it sounds. The basics are this; every time a device with a web browser comes to your site, the site asks a variety of questions in order to decide what the device is, what browser it's using and so on. What you need to do is insert a tiny snippet of code that not only detects the iPad but also changes where the site takes that user.

To do this you will need to insert some JavaScript into the "header" section of your website's code to prevent the Flash version from loading and show something else instead. How detailed you want to get is your decision. You could create a separate version of your site with no Flash but then if you're going to go to that amount of trouble, you may as well just redesign your site completely. A simpler and more convenient technique is just to use the aforementioned code, which you can quickly find through checking in a search engine, to divert iPad users to a single page where you can link to essential information.

To do this you will need to create a separate page that holds this information and include links to your galleries and other web locations such as Twitter and Facebook. This can be easily done in most web design tools, while a skilled web designer will be able to knock this up within minutes. A simple message reading "Welcome to my site. You appear to be using an iPad. For the best experience you can view my portfolio here or contact me at this address." is all that is needed. Within this message you can include hyperlinks to your iPad-friendly portfolio and your contact information too. While this method isn't ideal, it does mean that those visiting your site with an iPad won't be completely left out and can still see your work in some form.

LEFT Injecting an iPad specific code into your website header is a simple process when using services like Squarespace.

FLASH ON THE iPAD

The redesign method

The overhaul route is time-consuming and potentially a little more expensive, but will certainly be worth it in the long run. It also means you don't have to worry about injecting code into your site because it will be instantly viewable on an iPad without having to redirect the user. First things first: rid your site of Flash. It's easy to spot Flash content on your website when using a desktop computer by simply right-clicking on an element and inspecting it with the Google Chrome™ browser. Even easier, load the site on your iPad and spot the sections that don't work. More often than not it's just a few simple elements like animated banners or adverts that merely make the site look bad rather than not function, but if you have a gallery built in Flash you're going to need to do a little more work. In many situations you can simply replace the gallery within your site with one that doesn't use Flash. There are many widgets and plug-ins available for free on the web that don't use Flash and can be embedded into your site quite simply or you could lay them out yourself on a single gallery page to show them off to your site visitors. In most senses, it's only the snazzy transitions of a Flash-based gallery that you will lose when creating an online portfolio, not the quality of the images themselves.

As technology marches on to newer, brighter horizons, your website shouldn't be left behind and, if your site was made more than five years ago, you should probably consider an upgrade anyway. Fortunately, as a part of the relentless drive toward more consumer-focused technology, web design is no longer a dark art that only those in the know can perform. Unlike the days when hideous tools like Yahoo Geocities were the only way for the casual user to design a page, today you can build a professional-looking site in minutes with no experience and for little cost.

Squarespace

One of the best services at the moment is provided by a company called Squarespace, which offers both hosting and site design in one affordable package. The service can be tried free for thirty days and allows you to be as involved as you wish in the design process. Offering a selection of ready-made templates and a What You See Is What You Get interface, Squarespace is the ideal place for a photographer without HTML chops to build a quality online gallery. Squarespace doesn't hide the more complex elements of a website from you if you want to get more involved either, so adding snippets of code to your site (as discussed in the previous section) is as simple as cut and paste.

Many photographers are already using Squarespace as a way to showcase their work and there's even an iPhone app (compatible with the iPad) that lets you update your site on the move. Being an up-to-date system, Squarespace will design a site that is compatible with modern browsers and this includes the iPad. While external widgets may include Flash elements, a Squarespace site, on the whole, will look just as good on Apple's tablet as it does on the desktop. If things really take off for your website, you don't have to worry about buying extra server space either. Squarespace simply ups your allocation as and when it's needed.

Padilicious

If you want to get a little more hands-on with your online portfolio and create a version of it that's not only compatible but designed for the iPad, padilicious.com is your best bet. This superb website is built to help Mac users turn a simple web page into an iPad-centric swipeable affair, and includes tutorials on how to create your own iPad web app, which can be hosted in the same way that you host a web page. All of the files you need are available to download from the site and there are handy tutorials as well as examples to set you on your way.

You don't need to be a design genius or have any understanding of coding to carry out the techniques either. All you need is a little patience and a few hours, and you can quickly make the most of this excellent resource. Once you have created your web app you can make it a stand-alone page on your site or incorporate iPad functionality right into your website for a truly seamless experience. This includes swipe functionality as well as orientation support so your pages look great in both landscape and portrait view on the iPad.

BELOW This brilliant site will show those with time on their hands how to make iPad-friendly elements for their website.

MAKING USE OF iWORK

Apple's iLife suite on the desktop has a counterpart in the productivity space called iWork. Essentially an Apple-only version of Microsoft Office, iWork provides a spreadsheet tool called Numbers, a page layout tool and word processor called Pages, and a presentation package called Keynote. These apps offer similar features to Excel, Word and Powerpoint and are also available on the iPad through the App Store. While you will have to buy each app individually, it's Keynote that stands out as the major player for photographers, though the other two apps have their merits in certain areas and should be investigated.

...Keynote stands out as the major player for photographers...

Obviously, if you are already using a Mac, buying iWork is a sensible decision, as you can share your projects between your computer and iPad and take them on the road with you. You don't have to worry about compatibility issues if you choose to use iWork either. While Microsoft Office can't handle some of the more fancy tricks found in the iWork suite, the two play perfectly nicely together, with most Office documents readable in their corresponding iWork apps. In fact, when saving a document in Pages, Keynote, or Numbers, there is an option to save the file in common Office formats so you can send them to those using non-iWork apps. If there is anything included in your document that won't show up correctly in Office, the iWork app will tell you and suggest changes or make them for you. Since there is no version of Microsoft Office for the iPad right now it makes sense to use Apple's own tools. These not only provide all the features you need but also look the part as well. The three apps below come at a price, particularly if you buy all three, but when you consider the power on offer it's a price well worth paying.

RIGHT Apple's iWork.com is a handy tool when it comes to moving files between computers and users.

CREATING A CUSTOM PAGES DOCUMENT

If you're planning to share your work with others or simply need a fully featured word-processing tool on your iPad, you can't go far wrong with Pages. While many of the standard text editors on the iPad do a decent job of editing and storing text documents, Pages adds a layer of creativity allowing you to import images and adjust the layout of the page with simple strokes of your finger. There are also a number of default templates included with Pages on the iPad that allow you to add your own images. The templates range from letters to résumés and even projects, posters, invites, and proposals.

Created documents can be stored on the iPad or sent through email to Apple's iWork.com site or exported to another application. If you are using Pages on the desktop you can even send files to your iPad and work on them when you're away from your desk. As a photographer, the ability to access your portfolio when you're trying to create a letterhead or give a quick example of your photos is very useful. With all the images you need already stored on your iPad, you can create a professional-looking Pages document ready to be sent out to clients without even needing to touch your computer. For larger projects, a connected Bluetooth keyboard would be ideal, such as Apple's own keyboard dock, but for smaller tasks the on-screen keyboard works just as well with Pages.

RIGHT Pages works seamlessly well with iWork which will make your working life much easier.

Create and share a custom Pages document

Pages

1 Start by launching Pages and tapping the plus button at the bottom of the interface. Now select New Document from the menu that appears.

2 Pick a template from the selection available, choosing whichever one seems most related to the document you want to create. You can also choose a blank template and work from scratch.

CREATING A CUSTOM PAGES DOCUMENT

Create and share a custom Pages document

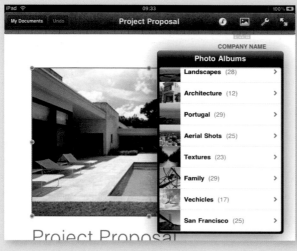

3 Any image included in the document can be swapped for one of your own. Do this by tapping on the image button at the bottom right of the image and selecting the picture you want to add from your albums.

4 Any dummy text in the document can be selected, deleted and rewritten as you wish using the on-screen keyboard. You can also copy and paste text into the document.

5 When you're done, tap the My Documents button to take you back to the main screen, then tap the Share button to send your document by email, upload it to iWork.com or export it to another app.

Just because you're working with figures doesn't mean you can't show off some of your creative skills while you do it. Numbers is Apple's iPad spreadsheet application, and it can do wonders for your bookkeeping whether you're in the office or out on a shoot. And it's not just a tool for budgeting with either. The app allows you to create all sorts of forms, charts and statistics and is an easy way to log data ready for use in iWork on the desktop or on your iPad when you have a spare few minutes. One very useful feature of Numbers is the ability to create a travel planner so you can cost shooting trips for clients and include travel and other expenses within the document. The output is truly impressive, with images and tables all available within the touch interface to make things look a lot more interesting than your standard spreadsheet.

As with all the iWork applications for the iPad, there are a number of preset templates to work with, so you don't have to start a project from scratch each time you launch the app. It's not all fancy design either; some serious calculations can be performed in Numbers, which uses an intelligent keyboard designed for entering dates, text, and numbers. The app is fully capable of creating and calculating formulas in the same way as a desktop spreadsheet tool. For costing a shoot or logging expenses this is an ideal application that, while not creativity-focused, could be an excellent aid to the working photographer.

Create a shoot checklist using Numbers for iPad

1 Start by launching Numbers and tapping the plus button at the bottom of the screen to load a new spreadsheet.

Numbers

2 Select a new Checklist template from the menu that appears by tapping on it.

CREATING A CHECKLIST USING NUMBERS

Create a shoot checklist using Numbers for iPad

3 A new blank checklist will now be loaded. Tap on any areas of dummy text to add your own information using the keyboard.

4 When you tap on the Date field a custom keyboard will appear allowing you to quickly add date information by specifying the day, month, and year using the display above the keyboard.

5 Enter text into the Task field to cover the various tasks involved in the current project, then repeat the process for all other tasks in your checklist.

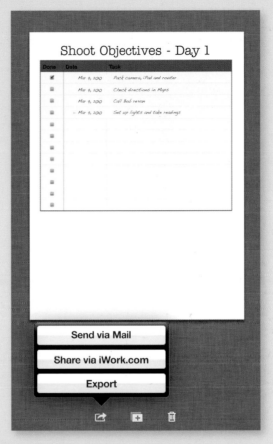

6 If you need to add another checklist or include more Tasks you can create a new one by tapping the tab with a plus symbol on it and select New Form.

7 To share your checklist with others, tap the My Documents button and then tap the Share button to bring up the sharing menu.

8 If you want to share your checklist as a PDF or send it for desktop use you can choose Export from the share menu to include it as part of iTunes' file-sharing configuration.

CREATING A SLIDESHOW WITH KEYNOTE

Keynote

The big draw for photographers when it comes to the iWork apps for iPad is Keynote. Keynote is a presentation creation tool—the same tool that Apple CEO Steve Jobs uses during his presentations. The iPad version has been completely rebuilt for the iPad, and in doing so it becomes the ultimate in portable slideshow creation tools. While you can add text and charts to your project, a photographer is likely to want to use Keynote on the iPad solely as a slideshow creator and it's as easy as pie to do just that. With simple touch screen controls and access to your entire photo library, you can quickly build a slideshow that includes music, animation, and some gorgeous transitions that can be triggered by touch or set to run automatically. You can hand your iPad to a client and wow them with your exceptional slideshow.

Every image you add to a slideshow can include a different transition and you can add stylish effects to each slide including reflections, shadows, and frames. You control the timing of each slide too, by setting a delay time between each so you can linger on a particularly beautiful image a little longer if need be. The choice is yours. A clever little feature called Magic Move makes the creation of a dynamic slideshow even easier by automatically creating an animation based on two slides you have created. This could mean that one photo blends into another or that an image shifts in position to allow another to take its place. There are literally endless possibilities within Keynote to show off your photos in style.

You can even connect your iPad to a larger display or a projector using the Apple VGA connector and share the show with an audience. Slideshows can be exported as a PDF document or stored and shared by email in the Keynote format ready to be viewed on compatible computers or iPads. If you're using the Keynote desktop software you can even export your entire slideshow as a movie to be viewed on a wide range of devices, or uploaded to your website or YouTube. As well as creating slideshows, Keynote provides a dynamic way to pitch for new business—using your iPad as a key selling tool—or give talks to others regarding your photography. As with the rest of the iWork apps on the iPad, Keynote comes with built-in templates that you can add your own images and text to, or you can build your own designs from scratch. For those worried about mistakes, the Keynote undo button is neatly positioned at the top of the interface and will even work after you've closed and reopened a document. The fact that such impressive slideshows can be created so quickly is a bonus in itself, but the ability to do so wherever you might be with your iPad makes the app even more essential to photographers.

LEFT Keynote isn't just for business presentations. It also allows you to make impressive custom slideshows on your iPad.

Create a photo slideshow with Keynote

Keynote

1 Launch Keynote from your iPad's home screen and tap on the plus button. Now select New Presentation from the menu to begin.

2 Pick a theme from the available templates by tapping on it. For slideshows, a larger, cleaner template usually works best.

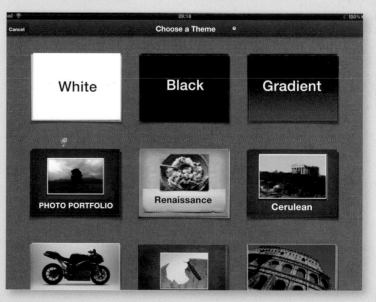

3 Tap on the dummy text and enter your own title text using the software keyboard. You can also move the text box if you want by tapping and dragging it.

CREATING A SLIDESHOW WITH KEYNOTE

Create a photo slideshow with Keynote

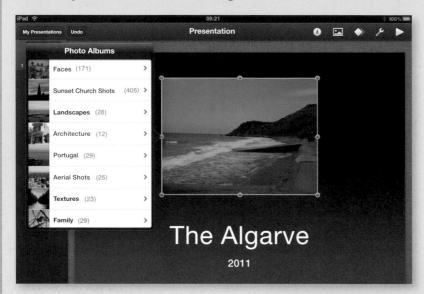

5 Now it's time to add a new slide to show off another picture. Tap on the plus button at the bottom left of the interface and pick a style.

4 Tap the button at the bottom right of the image in your template and select a cover image from your iPad's photo library.

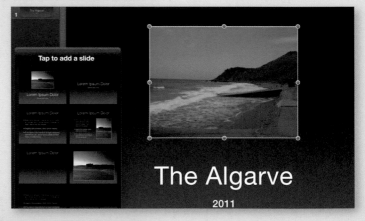

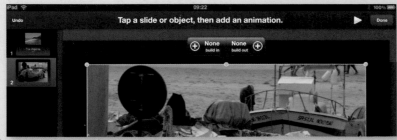

6 Add a new image in the same way you did in step 4 and then tap the Transition button, third from the right at the top of the interface.

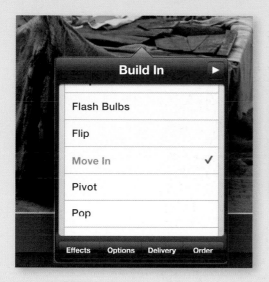

8 Tap Done and then select a Build Out effect in the same way. Repeat steps 4 to 8 until you have added all the photos you want to display and added effects to each.

7 Now tap the Build In button to choose the effect you wish to apply to your image as It appears. Tapping on an effect will preview it on-screen.

9 You can preview your slideshow at any time by tapping the play button at the top right of the interface. Make any changes you wish and then tap My Documents to return to the main screen.

10 You can now share your slideshow through email or iWork.com, or export it to another format or application by tapping the Share button.

iPAD AND APPLE TV

Apple TV is aimed at the consumer market, allowing users to rent and view movies and TV shows on their HDTV. When combined with the iPad it's the ultimate entertainment tool, working on a wireless network to stream content from the Internet or Macs and PCs in the house. Apple TV can be controlled from the iPad using the Remote app or a new system called AirPlay, which sends media from the iPad to the Apple TV with a single tap.

...Apple TV, when combined with the iPad, is the ultimate entertainment tool...

This is all very impressive, but how does it impact a professional photographer? Well, it's the Apple TV's ability to play slideshows that's the major factor here; for less than the cost of a cheap compact camera, you can add this device to your office or waiting area and wirelessly show off your images on an HDTV as part of a client presentation. Any slideshow available on your computer or iPad can be accessed through Apple TV, and you can choose the soundtrack from your iTunes library too. If you've exported slideshows as HD movies you can even choose to stream them through the Apple TV, playing them on the big screen while controlling playback from your iPad. What's more, Apple TV can be used to access MobileMe and Flickr accounts online, so you can quickly call up a specific album and share it with everyone from the comfort of your desk or living room. The device offers an HDMI port to send the video and audio signals to your TV and is small enough to fit in the palm of your hand. It also does a great job of streaming movies and TV shows if you have a little downtime in the studio. If you've been looking for a way to include an HDTV on your list of expenses for the year, the Apple TV might just provide the justification.

There are, however, a number of alternatives to the Apple TV that may suit you better and cost you a little less. The easiest one is to connect your iPad directly to your TV and show slideshows and movies you have created on the big screen, directly from the iPad. This technique requires the Apple Dock Connector to VGA or HDMI Adapter, but it does have limitations. Having to keep your iPad plugged in to a TV the entire time isn't ideal, as you'll inevitably need to use it and the method does rather limit its portability. Instead, why not consider a second display for your desktop? For a very small price you can add a new monitor to your setup, which is worthwhile for storing palettes when editing photos on your computer anyway. When you want to show photos, simply attach your iPad and spin the display around. Of course, when in such close proximity to your computer this may seem a little frivolous, but you can take the monitor wherever you happen to be—in another room or on another desk.

RIGHT The Apple TV is more than just a tool for watching movies. It's also ideal for photographers looking to show off images and slideshows on the big screen.

CONTROLLING YOUR COMPUTER

Control your computer with an iPad

Another approach is to simply use your iPad as a control device for a computer connected to a monitor. Whether it's a laptop or desktop machine, wirelessly controlling your slideshow from across the room using an iPad will be just as impressive to clients. There are many apps on the App Store that will allow you to use the iPad as a large trackpad, including TouchPad by Edovia Inc. This inexpensive and useful app uses Wi-Fi to turn your iPad into the ultimate in remote controls.

Not only can you drag your finger across the screen to move the cursor, but you can also use the keyboard. The app can be launched quickly from the home screen and dismissed just as fast, enabling you to quickly switch to a specific photo in your slideshow and give clients a closer look on the iPad screen. If you're using TouchPad in low light you can also select a darker theme so that the iPad's display doesn't distract from your presentation. TouchPad supports multiple finger gestures too, so you can scroll and drag as you would on a laptop trackpad or with a mouse. Mac users get even more features, including support for Apple's Front Row media center software plus Exposé and screen zoom, which can be performed with a simple pinch of two fingers. It's perfect for looking at images in more detail.

Another app for controlling your iPad is iTeleport, which actually displays your computer's screen on your iPad so you don't even need to be anywhere near your office in order to access all your files and software. There are two versions of iTeleport available, one for accessing your computer on your local network and a more expensive version that allows you access from anywhere in the world provided you have an Internet connection. Both versions have their merits, the local version for avoiding unnecessary trips back and forth from office to studio, and the other could prove to be a lifesaver if you happen to leave photos and other files on your computer while on location.

RIGHT Control your Mac or PC from your iPad with TouchPad or iTeleport. The ultimate in remote control.

Touchpad

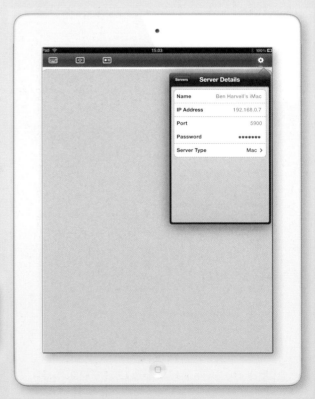

Use TouchPad to control your Mac with an iPad

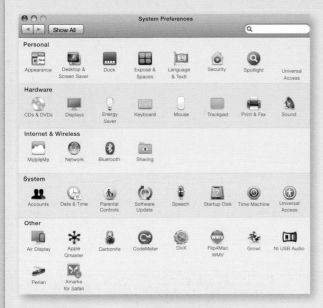

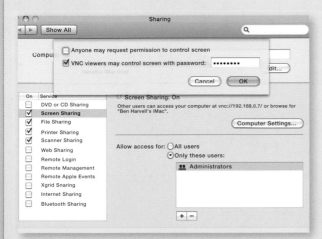

1 Start by downloading and installing TouchPad on your iPad then open System Preferences on your Mac.

3 Now click on the Computer Settings button and check the checkbox at the bottom. Provide a password to use when connecting TouchPad.

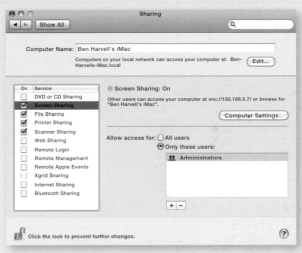

2 Next, click on the Sharing button and then check the box labeled Screen Sharing.

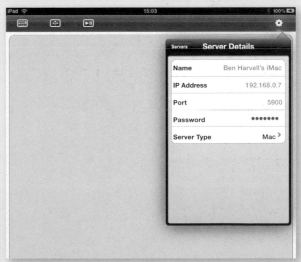

4 Click OK and launch TouchPad on your iPad. Make sure your computer and Mac are on the same network and enter your password when prompted.

CONTROLLING YOUR COMPUTER

Use TouchPad to control your PC with an iPad

1 Start by downloading and installing TouchPad on your iPad. Now download TightVNC from www.tightvnc.com. Install and launch TightVNC once it has been downloaded.

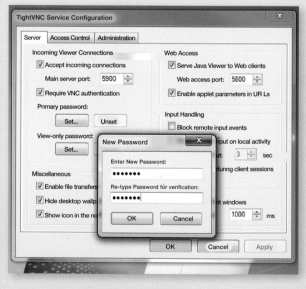

3 Make a note of the port number displayed and set a new password. Now click OK.

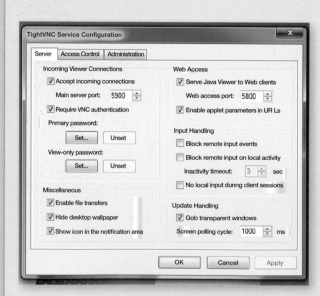

2 Find the TightVNC icon in the System Tray at the bottom right of the screen. Double-click on it to open the settings window.

4 Move your cursor over the TightVNC icon in the System Tray until a box containing your computer's IP address appears. Write the address down and launch TouchPad on your iPad.

5 Manually enter the server information using the port, password and IP address you have written down to connect to and control your PC.

Control your computer and share screens with iTeleport for iPad

1 Start by downloading the iTeleport app for your iPad as well as the desktop software available at www.iteleportmobile. com and make sure both your iPad and computer are on the same network.

2 Install the desktop software and enter your Gmail™ webmail service ID and password. If you don't have a Gmail account, you can create one at google.com.

3 Now launch the app on your iPad and follow the setup instructions. Once done you will be able to select your computer from a list and view and control its screen from your iPad.

ESSENTIAL ACCESSORIES

While we've covered a number of accessories already in this book, this is a complete list of iPad accessories that every photographer should consider. None will break the bank and all will add additional features or improve your day-to-day iPad use. Most of these accessories can be found on Apple's online and retail stores and if not, on third-party stores or manufacturers' websites. Take particular note of the protection options, as they will help reduce the kid gloves people have to use when handling such a stunning piece of fifty-percent-glass kit. With a decent bit of shielding you also won't worry so much about shoving your iPad into a bag or using it in extreme weather conditions.

...with a decent bit of shielding you won't worry so much about shoving your iPad into a bag...

A BRIEF NOTE ON MAKING MONEY...

Making money with an iPad

Part of the point of this book is to help you find ways of helping you save or make money using an iPad. Here, however, I want to talk about a more direct route, which some may appreciate and others may loathe. Whether you like it or not, there's a big market out there when it comes to stock photography, and a unique niche within that market is made up by iPad users. The iPad and its App Store is an awesome vehicle for the photographer to sell their photos through apps. Not all of us have the requisite skills to code and sell an iPad app, but there are plenty out there who do and will gladly partner with a content provider (you) to share the profit.

There are also plenty of existing applications that require photographic content that you could consider providing. One option you might explore, for example, is simply to offer background images for iPad users. Crop a nice shot to fit the iPad display in either orientation and you've got yourself a background. People won't necessarily pay a fee per image but if you sold a pack of iPad backgrounds on your site or by way of the App Store you could stand to make a nice little residual income for very little work, using images you may not have made any money from had you not experimented. If you want to get a little more serious about the iPad market you could even consider creating your own personal application to enhance your brand. Ideally free unless you really need to recoup the development costs, an app that shows off your photography could become the ultimate calling card for the modern photographer. There are hundreds of photo apps on the App Store but, with a little marketing and the right developer, you could quickly build a unique presence that will keep you ahead of the game. You might even pick up clients who have seen your work firsthand and want to see more. It might sound ridiculous, but there's a very real and very hungry market out there for the right kind of applications and the right kind of content.

IMPROVING DAY-TO-DAY iPAD USE

Apple iPad Smart Cover

www.apple.com

The microfiber case from Apple holds the iPad like a book, while the covering flap can also be used as a stand to elevate the iPad's screen for desktop use. When used in this formation you can even stand the iPad on its end to use it like a picture frame, although it's not a hugely effective way to use the iPad if you plan on touching the screen at all.

For iPad 2 users, the Smart Cover is ideal for protecting the screen and acting as a stand but doesn't cover the back of your device. Connecting via a set of magnets for easy attachment and removal, the Smart Cover also "cleans" your screen while it's on. Both of Apple's protection options are a little pricey but are worth the money in terms of convenience.

LEFT AND BELOW If you have a first generation iPad then Apple's original cover is the ideal option. iPad 2 users, however, have the benefit of the magnetic Smart Cover.

RIGHT The Apple iPad Smart Cover.

Zagg invisibleSHIELD

www.zagg.com

With a Zagg invisibleSHIELD on your iPad it can resist scratches from keys, nails and even small power tools—not that you would ever want to test these claims. The clear film, placed on the front and back of the iPad, uses military-grade material that can actually heal itself and, many believe, enhances the iPad's already impressive screen. Fingerprints, smudges, reflections, and glare can all be reduced with this product, which has been widely lauded across the web and in the tech press. If you're worried about scratches on your precious iPad screen, then this is the protector for you.

IMPROVING DAY-TO-DAY iPAD USE

Pogo Stylus

www.tenonedesign.com

It's great to be able to control your iPad and its apps with a mere motion of your finger, but, when it comes to more precision tasks such as handwriting and photo retouching, a finger doesn't make the best tool. Ten One Design has introduced a clever and very cheap pen that works with the iPad screen and offers the same precision you would expect from a regular pen or a graphics tablet. The Pogo Stylus can also work on the trackpad of a MacBook or MacBook Pro, and can even be bought with an additional case that allows the pen to clip to the side of your iPad while not in use. When it comes to fine-tuning images or sketching out ideas, this little pen will make a great deal of difference to the way you work.

Griffin A-Frame Stand for iPad

www.griffintechnology.com

While Apple's docks are good for using the iPad in portrait orientation, they don't allow you to stand the iPad on its side. You are also forced to view the iPad at the same angle each time you place it in the dock. Griffin's A-Frame lets you position your iPad however you like and at an angle that suits you. The simple frame design acts like a hinge and the iPad sits in a small groove to stop it from sliding out. The A-Frame also folds up neatly so that it can be packed into a bag. You can even attach your iPad to a connector cable so it can sync and charge while in the stand.

Incase Car Charger

www.goincase.com

Known for its stylish protection products, this little charger is a bit of a departure for Incase, allowing you to charge your iPad using your car's cigarette lighter as a power source. The device offers an LED charge indicator and will also provide charge to iPhones and iPods, making it an ideal glove box companion for traveling or working on location.

Apple Camera Connection Kit

www.apple.com

Apple's solution to connecting a camera to your iPad comes as a two-part adapter that provides an SD card reader and USB socket. The SD card reader transfers images, as you would expect, from an SD card, while the USB socket allows for direct connection to a camera via a USB cable. Both methods import the images to your iPad's Photos app where they can be shared to galleries, edited or emailed to others. If you're using a 3G iPad this can be a handy way to send out preview snaps from a shoot without needing to take your laptop with you.

IMPROVING DAY-TO-DAY iPAD USE

Apple iPad Keyboard Dock

www.apple.com

The inexpensive Apple iPad Dock is essential for those who use their iPad on a desk, providing a convenient way to keep the device upright and to charge and sync at the same time. The keyboard dock offers the same features, yet also offers a small keyboard that can be used to input text into email and word-processing apps, making it perfect when you're away from your desk or traveling. If you already have a wireless keyboard that can be connected via Bluetooth you can also pair that with your iPad for portable use.

Logitech Keyboard Case by ZAGG

www.zagg.com

If you want a more convenient way to write emails or update your website from your iPad you should look at the Logitech Keyboard Case by ZAGG. The solid aluminum design not only protects your iPad when it's not in use, but doubles as a Bluetooth keyboard that connects wirelessly with your iPad. It's quite a cramped space to type in, but for its portability this is a welcome addition to your kit bag.

Aquapac Waterproof Case

www.aquapac.net

It's never a good idea to mix technology and water, so this interesting protection option from Aquapac should be an essential part of your outdoor photography kit. Fitting the iPad snugly, the waterproof case protects your prized tablet from the elements and will even float on water should you use it in more extreme locations. You can control the touch screen through the transparent casing and the Aquapac even provides neat eyelets to let you attach your iPad to a bag or pretty much anything else. The TPU housing is resistant to UV, tearing and temperature change, and it features a handy shoulder strap for when you're out and about. The next time you're out shooting in severe weather, at sea, in snow or on a beach, the Aquapac will offer a little more peace of mind. The company also offers waterproof casing for compact and SLR cameras too, keeping all your kit protected from the pitfalls of nature.

Power Traveller Solargorilla

www.powertraveller.com

This handy piece of kit allows you to do your bit for the planet. The Solargorilla is about the same size as an iPad when closed, but when opened it reveals two solar panels that turn the sun's rays into power for your device. The charger comes with a range of adapters including one to connect to your iPad's dock connector. So if you shoot outdoors frequently, preferably in bright sunlight, this could become an invaluable tool. The device is especially useful if you spend time shooting in remote locations.

MUST-HAVE iPAD APPS

While we have already mentioned some great photography-related applications, there are thousands more to discover on the App Store. In this chapter you will find a handful of some of the best applications for the iPad: apps that will not only add exciting new features to your device but also those that help you interact with sites and services you may already use. Beyond that, there are also applications that, while not offering much in the way of workflow-enhancing power, will provide great inspiration to you as a photographer, which is crucial if you want to keep your work fresh and interesting. From tools to edit your images and organize them online, to apps that will help you engage with clients in unique ways, this section is all about showing you just what is out there when you scan through the photography category on the iTunes App Store. There are always duds, but the apps listed below are shining examples of the kind of quality that is also available. Best of all, some of them are completely free!

...from tools to edit your images to apps that will help you to engage with your clients in unique ways...

DISPLAYING PHOTOS

Bill Atkinson PhotoCard

Bill Atkinson is not only a professional nature photographer—he's also a great application developer, who has worked on Apple platforms to create such legendary programs as HyperCard, QuickDraw, and MacPaint. His PhotoCard application is an excellent example of a photography mind working in sync with the possibilities the iPad affords, and one that provides an impressive service to boot. Simply pick an image on your iPhone or iPad and you can send it directly from your device by email or regular mail as a professional-looking, high-quality postcard. Fun extra features allow you to add stickers and stamps and, if you're sending your card by email, you can even send a voice greeting to go along with it. This app is an excellent way to contact existing clients in a more engaging way, not to mention lure new customers.

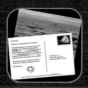

Photocard

Masque

Masque is a well-thought-out tool that makes the most of the iPad's large screen and touch interface to allow the user to apply effects and perform image adjustments. You can pull images from a number of sources including Facebook, Flickr, or pictures in your iPad photo library, and make subtle or dramatic tweaks to your photos in seconds. Effects can be layered on top of one another, while advanced tools allow for gradients and brush adjustments to be painted onto an image with a finger, giving you complete control over the changes being made. Excellent for experimentation, Masque adds a new level of creativity to your photo editing on the iPad and allows you to share your work through email, Facebook or Flickr. A light version of the app is also available so you can try before you buy.

Masque

Tiltshift Generator

You might well write off this app as a gimmick but in truth it provides some unique tools to create some quite remarkable effects. Effectively faking the work of a DSLR, Tiltshift Generator makes it possible to adjust the depth of field of a shot to create spectacular visual illusions that even your camera might not be able to produce. The app offers a simple interface and some basic editing tools alongside the main controls. This is one of those apps that you won't use every day, but it offers an interesting way to manipulate your photos for specific project needs—or just for fun!

Tiltshift Generator

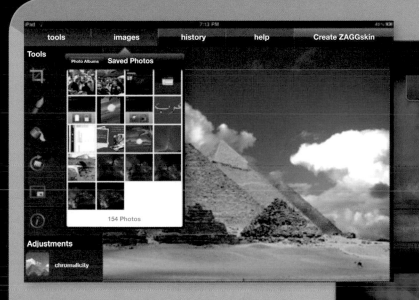

Photopad

Offering the standard set of editing features you would expect from any photo-editing app on the iPad, PhotoPad goes one better by providing very fast edits and including a number of interesting additional features. The app is updated regularly and offers a number of adjustment and positioning tools as well as effects. Made by ZAGG, a company that also makes iPad skins, you can design your own skin for your iPad within the app and order it from the website. It might be a little gimmicky, but think how this could work as a gift for your iPad-using clients...

Photopad

You Gotta See This

Originally for the iPhone 4, this app lets you create panoramic shots in a multitude of styles by simply sweeping your iPad's camera across a landscape, using the in-built gyroscope to piece individual shots into one image. While this won't produce professional-quality images, they can provide a fun addition to projects or as sample shots to showcase a proposed location. Saved images are stored to your iPad's Camera Roll and can be shared using any methods you already use, including email.

You Gotta See This

PHOTO-EDITING APPS

Photogene

The most fully featured iPad photo editor available, Photogene doesn't cost the earth and allows you to make simple or more complex edits on the fly—even when you're on location. The app was designed specifically for the iPad and makes good use of the available screen space providing red-eye correction, cropping, and color adjustments. You can transfer an image to your iPad during a shoot, make basic adjustments to the shot and fire it out by way of email within seconds. The app even works with Raw files and can store images to the iPad photo library or send them to Twitter, Facebook, and Flickr.

Photogene

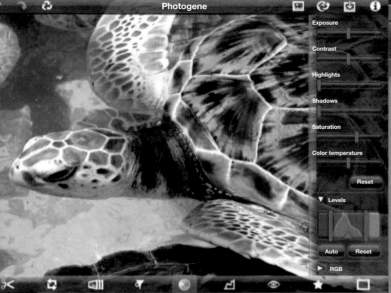

Impression

Don't wait until you get back to your computer to watermark and share your images; do it on your iPad with Impression. Offering one and only one simple feature, this free app allows you to add text to an image as a watermark and then adjust the opacity and color to suit your requirements. If you want to share an image from the field but are worried about copyright infringement, this will be your go to iPad app from now on.

Impression

INSPIRATION AND LEARNING APPS

100 cameras in 1

A fantastically fun way to see how different photo effects look on your photos, full-screen, before tweaking the effect to suit your taste. You can pick any photo from your library, then just swipe left or right between the whimsically named effects ("The old shed that always scared me," for example). Once you've found one you like, tweak the sliders to change the "Yin," "Yang," brightness, contrast, or add a vignette.

Guardian Eyewitness

Less a tool and more of an inspirational app for photographers, The Guardian's Eyewitness app gathers the last 100 images from the Guardian's Eyewitness photography spreads, selected from thousands, and displays them within a beautifully designed iPad application. New images are added regularly and each image can be marked as a favorite and shared through email or Facebook. The app is great for anyone who appreciates quality photography, though the Pro Tips feature, which provides professional insight on each shot, is also a valuable learning tool.

NPPA

Whether you're a member or not, the National Press Photographers Association app offers a great source of news for a variety of photographic disciplines. Listing breaking news, as well as information on workshops and seminars, the app isn't particularly aesthetically pleasing, but as a resource it's certainly worth having.

Guardian Eyewitness

NPPA

Reuters Galleries

This free app gathers the best of Reuters' photographic and video content. The photography is, unsurprisingly, very impressive, providing a unique way of viewing the news through images and video. The app is updated daily, and also has a slideshow view and options to share images with friends. Each includes a small caption to explain the story, while video clips round up the latest news.

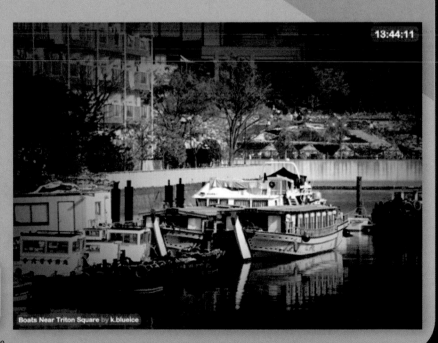

Reuters Galleries

Flickr HD Photoframe

Making use of the full iPad screen, this app offers full quality HD images from the Flickr account of your choice. While you can set the app to move through your own Flickr photos it's also a neat way to view the photos of others for a little bit of inspiration during your downtime. The app works with both free and pro Flickr accounts and can be set to random. You can also save images directly to your iPad photo library and share them through email if you wish.

Flickr HD Photoframe

Todo for iPad

Why take a real binder out on a shoot with you when you can have this virtual assistant stored on your iPad? Keeping track of your day-to-day or shoot-specific tasks has never been easier than it is with this beautifully designed app, which helps you plan and carry out activities using simple checklists and organizational tools. The app can sync back to your computer to keep you up to date at all times and it's fully compatible with the contacts and calendar apps on the iPad, ensuring that you can also send out information to others. You can even set alerts and prioritize events on your to-do list by order of importance if you wish. For keeping yourself organized with your iPad, Todo offers the right mix of form and function.

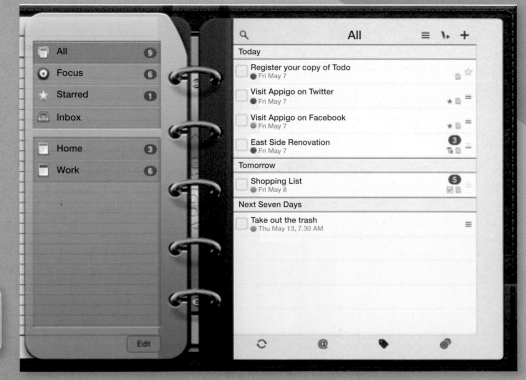

Todo for iPad

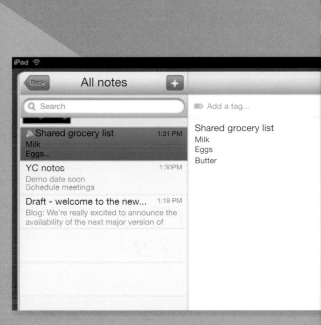

Simplenote

Don't scrabble around looking for paper and a pen each time you need to make a note, use Simplenote to not only jot down important info, but keep it all in one place and share it with others. All of your notes are synced back to the Simplenote website, so you can access them from anywhere and don't have to worry about losing your data either. The app is free to download and ideal for drafting emails, recording data or making lists.

Google Mobile App

Let your iPad help keep you organized. Google's Mobile App, available for both iPhone and iPad, allows you to search by voice and uses your current location as a reference. The app also allows you to quickly connect with other Google services such as Gmail, Google Calendar, Picasa, and Maps with a single tap, making it a one-stop shop for all your communication, navigation, and organizational tasks. Other search features include a contact search, Google Suggest, and you can even set the app to send you a push notification when you receive new emails or calendar events. If you use one or more of the Google services you need to install this free app on your iPad.

Simplenote

Google Mobile App

Wolfram|Alpha

How many times per day do you ask yourself questions like "How far is that in miles?" or "What's that in dollars?" Wolfram|Alpha can answer practically any question you can throw at it. Whether it's a simple conversion or calculation or a more complex geographical or historical query, the app does its best to read your input and formulate an answer based on its own knowledge and the power of the web. There are even built-in tools for photography too, including ƒ-stop arithmetic, subject magnification, depth of field, hyper-focal distance, and more.

Wolfram|Alpha

Documents To Go

Think of this app as Microsoft Office for your iPad, enabling you to open any Word, Excel or Powerpoint file, as well as many others, from Apple's iWork. You can import and edit any document on the iPad using Documents To Go and then share it with others through email, or sync files back to your desktop to make sure they remain current. One of the major features that Documents To Go offers over other Office-like apps is its ability to work with sharing services like Dropbox. Simply connect to your account, work on the shared files and then save them back to your shared folder. Believe it or not, a large portion of this book was written using Documents To Go and Dropbox.

Documents To Go

iDisk

iDisk

If you're still using Apple's MobileMe service you'll also be allocated a chunk of online storage known as your iDisk. You can copy files to this online storage space from your computer or by way of the web and access them on your iPad wherever you have an Internet connection using the iDisk app. Files are sorted into folders and, if you are sharing a public folder, you can transfer files to your iDisk for someone else to view and vice versa. Storing your essential files and images on an iDisk is the easiest way to access documents without taking up space on your iPad's hard drive. Be quick though, the service expires in 2012.

Thanks to the iPad's networking capabilities and Adobe's ingenius extensions to Photoshop, it's now possible for developers to create apps which let you use your iPad to control the photographer's most established tool, Photoshop. Adobe have led the way by creating some handy apps to get you going (and prove their point).

Nav for Photoshop

Putting the Photoshop Toolbox at the tips of your fingers, Nav for Photoshop creates a link with your computer over Wi-Fi and gives you quick and instant access to the main controls.

Nav for Photoshop

Eazel for Photoshop

Like watercoloring with your fingers, this app will let you play with color and see how it mixes. Tap all your fingers on the screen to bring up the options, and send the result to Photoshop.

Eazel for Photoshop

Color Lava for Photoshop

A color-mixing tool that replaces the classic Color-Mixer panel in Photoshop with a more natural approach that might appeal to those of a more painterly disposition.

Color Lava for Photoshop

Goodreader

If you don't feel the need for a full office suite, you can keep your iPad compatible with most document formats with the reasonably priced app, Goodreader. The app is designed for viewing large PDF and TXT files, but it also handles a wide range of other document formats. Using a unique reflow technology, Goodreader extracts pure text from PDF documents and flows them onto the iPad's display with text wrapping and search features included. Compatible with Apple's Dropbox and many other online services, you can access your files wherever you are within Goodreader and even open non-iPad-native mail attachments in the app.

Goodreader

Dropbox

Dropbox has been referred to a number of times in this book, and the reason is simple: it's an essential tool for keeping your files up to date on your iPad, as well as across all your computers. Simply create an account via the Dropbox website, install the software on all your computers, and your iPad and files will be available wherever you are. You can even edit files on one computer and see the changes reflected on all of your other devices. You will need an Internet connection in order to make use of Dropbox and ensure all your computers are connected to stay completely in sync. But once that's done, there's no other setup to perform. Many iPad apps are compatible with Dropbox syncing too. Best of all, the app is completely free and provides 2GB of storage.

Dropbox

Photobucket

If you're already a Photobucket user then you'll know that it's a useful online storage resource for photos and video, working in the same vein as Flickr. The Photobucket app offers a way to send images on your iPad to your Photobucket account and even caters for Geotagging and a host of other interesting features. Differing slightly from other online gallery-based apps, Photobucket for iPad also allows users to search and download any image from the site as well as share images through email. Albums can be edited and created from within the app and individual images can be named, renamed and deleted on the fly. For a free application, Photobucket offers a decent bunch of features—almost enough to make you think twice about your current service if you're not on Photobucket already.

Photobucket

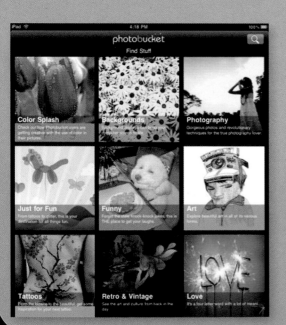

MobileMe Gallery

One app to definitely take advantage of is the free MobileMe Gallery app. Designed for the iPhone, it works fine when blown up to twice the size on an iPad and, while it won't provide the most incredible portfolio viewing experience in comparison to a native iPad app, it's still handy for quickly viewing your published albums and sharing them via email. The interface includes an attractive scrolling panel at the top of the display, which shows off a random selection of pictures. You can dip in and out of albums with a single tap.

MobileMe Gallery

Photo Slides

Another app for showing off your photos rather than manipulating them, this clever and inexpensive app connects to Flickr and displays a slideshow of images from the site. What makes Photo Slides exciting for the photographer however, is its ability to search for photos you've tagged on Flickr. You can set a slideshow of your most recent images or your entire gallery while your iPad isn't in use or when showing your work to others. The interface isn't beautiful but then you don't want fancy graphics distracting viewers from your photos now, do you?

Portfolio To Go for Flickr

This app is ideal if you want to take your photos with you wherever you have your iPad and an Internet connection. And even if you can't access the web, you can cache galleries for offline viewing, not to mention view all of your galleries using the Photo Wall, and send specific galleries to clients via email. You can also share images through Flickr links on Facebook and Twitter. The interface is easy to use, which is great news if you want to showcase photos to clients and let them flick through them for themselves. If your primary source of online photo storage is Flickr, this is one app you won't want to be without.

Portfolio To Go for Flickr

Photo Slides

ESSENTIAL ONLINE SERVICES

As a photographer, you no doubt have favorite services that have served you well over the years. I certainly don't want to sway your loyalty or suggest change for the sake of it, but in this chapter you will find some iPad-centric services that will help you better use your device. In an increasingly online world, the ability to keep apps and services synced wherever you are, on your desktop computer, laptop and iPad is essential. By using services that are iPad-friendly you'll be helping yourself stay organized and reduce physical syncing times with updates to your files and folders happening over the air.

...by using services that are iPad-friendly you'll be helping yourself stay organized...

SERVICES FOR iPAD PHOTOGRAPHY

Photobucket

Photobucket merges social networking with image hosting to provide a unique way to share and link to your photos and videos. The service allows you to edit pictures on the site too and share them on sites like Facebook, Twitter and MySpace. With a free iPad app available, Photobucket is a great option for iPad users and provides an easy way to view your photos on your iPad when you're away from your desk.

Photobucket

Flickr

Flickr is quickly becoming the go-to image hosting service on the web, providing a wide range of images for a worldwide group of users sharing over four billion photos. The site is both clean and functional and there are a number of applications for the iPad that allow you to access your images on Flickr, including Portfolio To Go. Images can be shared, geotagged, and set with varying privacy controls and usage rights.

Flickr

SERVICES FOR iPAD PHOTOGRAPHY

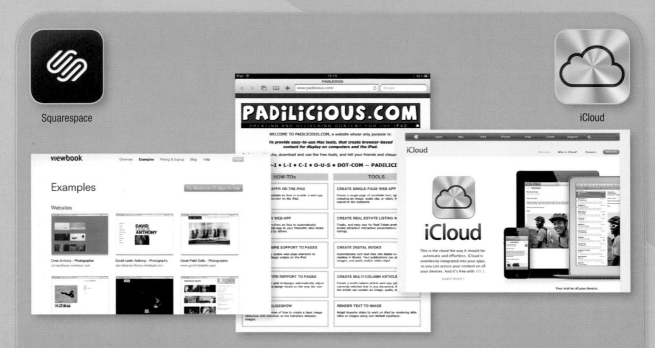

Squarespace

iCloud

Squarespace

Squarespace.com is probably the best service for creating your own portfolio website. The site assumes no experience on the part of the user but allows you to delve into the code of your site if need be. Offering beautifully designed templates and photo gallery pages, you can create a professional-quality site in minutes without the cost of a web designer, and your site won't look templated or like any other. Squarespace offers a varied pricing structure and its servers adjust to the demand for your site. It should survive even if your work starts getting some serious attention.

Padilicious

Padilicious.com offers all the files and instruction you need to create iPad-oriented web applications that include swiping capabilities and more. The site is free to use and the support files free to download; the only thing you need to invest is the time to make your apps and add them to your website so that fellow iPad users or yourself can show off portfolio images in style. There is a selection of guides available on the site and more are added frequently, so check back often for the latest tips to enhance your online presence for iPad users.

iCloud

iCloud is the ultimate wireless storage service for iPad users, combining music, photos, apps, calendars, documents, and syncing across all of your computers and compatible devices. Taking over from Apple's MobileMe service, it integrates seamlessly into your apps, so you can access your own content on all your devices. It also comes free with iOS 5. The syncing tools mean that new info is "pushed" to your iPad, including email and calendar updates.

Photoshop.com

If you use any of Adobe's apps such as LightRoom or Photoshop or even the entire Creative Suite, you should investigate the features offered by photoshop.com for sharing and editing your images online. The corresponding Photoshop Express iPad app makes accessing and adjusting your images easy when you're away from your studio. If you're used to the Adobe layout, the website and app will also be very familiar to you and so easy to use.

Photoshop Express Viewbook

Viewbook

The guys at viewbook.com are well aware that photographers use the iPad in their work and, as such, have created a way to design professional portfolio websites, photo galleries and presentations that work seamlessly with your tablet. Images stored on Viewbook can be promoted and organized and you can even sell your images from the site. A free 30-day trial is available at viewbook.com so you can sample all the great features.

PROFESSIONAL PERSPECTIVE

It's all very well having me explain how the iPad will change the way you work as a photographer—and I have no doubt that it will—but it's always nice to hear the same from like-minded souls. Photographers, on the whole, are a traditional bunch in many respects; they tend to gravitate toward new technology that will actually be of use to them. The iPad fits that mold perfectly. Many of the world's top photographers and photography experts have taken to the iPad for use in their work, with a number dropping a laptop out of their professional work entirely in favor of Apple's tablet. It's encouraging, when writing a book like this, to hear that so many respected imaging professionals agree that the iPad is an ideal tool for the modern photographer. I've had many conversations with photographers using the iPad throughout writing this book and in this chapter you will find a selection of their thoughts, covering how they use the device as part of their workflow, and how they think it will make a difference to photography in general.

> ...the iPad is an ideal tool for the modern photographer...

COREY RICH

Professional photographer
www.coreyrich.com

The iPad has really revolutionized the way I interact with clients in terms of showing work, both still photography and multimedia projects. I think we all as photographers are visual storytellers moving into the future; it's no longer just about single images, it's also about moving picture video sequences of stills and audio to tell more complex stories. The conventional portfolio book just doesn't work and the iPad has really become the perfect platform for showing everything from still photos to video to prospective clients.

I find that I'm carrying the iPad with me everywhere. A great example of this was during a shoot in China at a new national park on the northwestern border near Mongolia. At first the park officials were not interested in allowing us to climb the unclimbed rock faces in the park, but I had my iPad in my camera bag and had the opportunity to pull it out and show a two-minute movie that I shot in Yosemite National Park about rock climbing. That movie actually allowed the officials in the park to understand what we were trying to accomplish and so, in theory, the iPad became our key to gain access to the national park.

FREDERICK VAN JOHNSON

Professional photographer, lecturer and host of This Week in Photo (TWiP)
www.frederickvan.com

I mainly use the iPad as a viewer for in-the-field photography. For example, if I'm on a trip I can use the iPad to quickly look at the images I've captured on location. You could always do everything the iPad allows; however the device brings extreme portability, as well as a friendly user interface to the task of previewing and selecting images.

The fact that the iPad is a platform and not just a purpose-built device is its greatest power. Developers are continually creating new and innovative imaging applications to run on it, and photographers are the beneficiaries of this renaissance of creativity. I would love to see Adobe Photoshop Lightroom ported to the iPad—considering the modal user interface in Lightroom it seems an ideal fit.

In terms of apps, I've mainly standardized on PhotoGene and TiltShiftGen. Those are my go-to apps, though I have a list of apps that I "play around" with from time to time. I don't think the iPad will become "standard" per se. Photographers just need a good camera and lens to capture images. Tools like the iPad and others augment the workflow, but not every photographer has the luxury of being able to purchase one.

HANNAH GAL

Adobe evangelist, professional photographer, illustrator, and filmmaker

www.hannahgal.co.uk

The iPad's light weight has introduced a new level of ease into my professional life. It's brought a smarter way to display, edit, and share work. Its crisp, large screen injects addictive aesthetics into all it touches, boosting personal portfolios no end. I use the framed photo feature to assess work in progress and Portfolio To Go for presenting work to clients and colleagues. Any other method, including the snazziest laptop around, now seems archaic, and yes, it beats the poshest leather portfolio, too. Viewing the portfolio is no longer the passive turning of pages but a truly interactive experience. Viewers browse through categories, enlarge an image for detailed view, get further info on any given image, mark shots of interest, load images onto their personal system and more.

My use of iPhoto has also been elevated to a higher level with intelligent organization and smooth connectivity to all things Apple. Besides the inevitable mail and Internet, many apps have made the transition from my iphone, including Dropbox for live file sharing with clients and editors. There is the practical Notes and countless other great creative apps that garnish presentations and add an element of fun.

SCOTT BOURNE

Photographer, new media producer, consultant, author, and lecturer

www.photofocus.com

One photographer wrote me a very long email (3000 words or so) explaining how the iPad was a failure, etc. He kept saying things like—"It won't handle Raw files." "How will I move files from the iPad to the computer?" His constant use of the word FILES got me thinking. This guy doesn't understand Steve Jobs. Steve Jobs doesn't talk about files. He talks about pictures and music. After all, these FILES are pictures. Apple makes products you can DO stuff with. You use the iPad to look at and share pictures, not files.

Interacting with PICTURES on the iPad is going to be very different from the way it's done on a computer. There's no mouse, trackpad or trackball. There's no programming. There's no learning curve. Three-year-old kids will start using an iPad successfully within three minutes because the iPad is about the content, and the interface that lets you access that content.

In short, I see the ability to interact with the iPad via multi-touch as a new opportunity to show off your photo portfolio with flair. Not only will you be able to show pictures, but if you become skilled at multi-touch gestures, you'll be able to do it with style. The ability to use the iPad as a portable portfolio is its main attraction.

:KELLY GUENTHER

Professional photographer
www.hockleyphoto.com

I'm a wedding and event photographer and I bought the iPad the first week it came out to do a little guerilla marketing at a trade show. I walked around the bridal expo, casually looking up things on the iPad. Inevitably a curious bride/groom would say "Is that the iPad?" I'd show them how it worked by scrolling through my wedding portfolio. "Did you take these?" and so it goes. I booked two weddings that day. I love it. I'm so much more portable now, I can take meetings anywhere and the screen is so sharp and bright, it really makes my photos pop. When I exhibit at trade shows I use it in slideshow mode as another monitor or book appointments on the spot using iCal. I can't say enough great things about the iPad.

:WADE LAUBE

Photographic editor, *The Sydney Morning Herald*
www.wadelaube.com/blog

It's as if Apple built the iPad specifically with us in mind. It's a great device for showing your portfolio to a client or an editor and it's an equally good wireless monitor for shooting on location. What the iPad is not, however, is a post-production device. I am not discounting that one day it may well mature into one, but at 64GB there isn't enough memory to hold a decent-sized library, and moreover, professional post-production software is yet to migrate to the platform. Having said that, I don't believe Apple ever intended for the iPad to do this sort of thing. After all, that's why we have laptops, and it's why we will continue to have them for a long time yet. But the fact that it doesn't replace your laptop is not a measure of the iPad's success; it really is an entirely new platform.

For showing your work to clients it's perfect. At around the price of a professionally bound book, you can have several portfolios ready to call upon as needed. Its most valuable function for us, however, is wireless tethering. Use it in conjunction with an app like ShutterSnitch and you'll get a real-time, full-screen monitor, together with simultaneous on-the-fly backup. That alone is worth the price tag.

:SIMON FAZACKARLEY

Professional wedding photographer
www.fazackarley.com

As a wedding photographer, I'm always on the lookout for technology that will help me provide a better service for my clients. Being a long-term Apple fan the iPad was an obvious choice when it came out. When I'm in the studio I have the iPad in a dock, and use it for managing my emails—leaving my main computer focused on editing all the gorgeous pictures! I also have an app that manages my endless to-do lists and helps me keep on track with workflow and my various client relation commitments.

The ability to carry a current portfolio with me everywhere is a huge advantage and means I'm ready to wow prospective clients wherever I meet them. This also means that during my meetings, I'm showing potential clients images from weddings as recently as the past weekend. I've found it invaluable being able to show work to prospective brides as they can really see my style, which is constantly evolving. The alternative would be a more traditional wedding album—which is expensive and therefore costly to keep up to date—in this respect, the iPad is saving me money! Wedding albums also take weeks/months to produce, so by the time it arrives, it's already out of date.

:AARON B. HOCKLEY

Professional photographer
www.hockleyphoto.com

The iPad is an excellent mobile portfolio device. As I meet new folks (whether planned or impromptu) I can easily show off my various portraits, corporate/commercial images, and fine art photography. Handing my iPad to someone and allowing them to browse my portfolio at their own pace is a very casual and intimate gesture which helps the viewer connect with the photos. Managing the mobile portfolio is done via a publish collection in Lightroom 3 using a folder that I have synchronized with the device via iTunes.

In addition to being a photo-viewing device, the iPad is an excellent mobile business tool (which has replaced carrying my laptop for most purposes). I use my iPad on the go to read and respond to email, review contracts and invoices, and research photo venues and related information. When at a networking event, trade show, or conference, the iPad is an awesome note-taking device. Even while disconnected, I can invite folks to sign up for my email newsletter through MailChimp. The iPad is the portable "brain" for my business; having the information and functions available has led to increased business.

TERRY RUNION

Professional photographer
www.newlifeimages.com

The first thing that came to mind when I got my first iPad was to use it as my "portfolio book."

I quickly realized the potential of the device, which I really don't think has been fully realized yet. Within about a month I found an app that allowed me to create a legal document like a model release or a rights usage document. I began taking my iPad to shoots, and using it for legal documents. Just think of how much easier it is to have an electronic copy of a model release that the model and I can read and sign right on site. The app actually allows me to collect signatures, and once it is completed, emails a copy to the model and to me. I then keep that in my email system to provide a backup of the document.

When I travel to shoots I often shoot many memory cards and then at night, back in the hotel, I download those images to an external hard drive, which requires bringing one along with my laptop. So I ordered the iPad Camera Connection kit that is designed to connect to my camera, and the iPad became an instant storage device. Now I can use the device for my legal documents and as storage. Once I return home I simply sync the iPad with iTunes, and import the images into Adobe Lightroom.

ROSIE TANNER

Editor, *Digital Photographer Magazine*
www.dphotographer.co.uk

For me, the iPad acts as the ultimate portfolio. Its portability means that you can carry it everywhere and the screen is the perfect size to share your shots with prospective clients. Not only is it far more convenient to travel with than a laptop, but it looks slicker too—and first impressions are such an important factor when showing off your work.

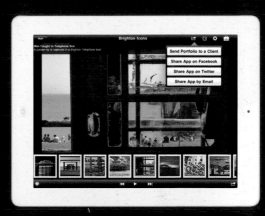

CLOSING COMMENTS

So you've heard it from me, you've heard it from other professionals and you've heard it from the app developers: the iPad really is a great device for photographers. It enhances the way you work and it cuts down on the amount of equipment you need to carry with you when you're out on a shoot. It's not quite the perfect tool that it could be but, at the end of the day, it's still a consumer device. The difference it offers over other devices, however, is that it is constantly evolving through software. If there's a need, a developer will fill the niche and

we're already seeing many great photography apps and expect to see many more.

I hope I've been able to open your eyes to a few uses you may not have thought of, a few apps and accessories that you now can't do without, and I hope I've excited you about the iPad enough that you seek out your own techniques and tricks to help you in your daily work. As with many publications of this type, it will be updated as things change but it won't be current forever. The iPad will be revised, hopefully adding some of those crucial features we're all waiting for, and the Internet will catch up even further with the mobile revolution. Even if none of those things happen, there's one fact that isn't in any doubt—the App Store will keep on churning out apps.

A number of these applications will fall into the photography category, and the beauty of the App Store is that it just takes one guy, a little developing know-how, and a brilliant idea to create the next big hit. Incredible tools for the iPad photographer are right around the corner and even more advanced software is being developed as we speak. If the chapter on making money with your iPad excited you, remember that if you need an app to do a specific task and it's not available, the likelihood is that others will too. Many

of the best iPad apps were born from a necessity rather than a brilliant idea so if you don't see it, why not make it?

It's up to you now to make use of the options the iPad affords, and to let it make your working life easier, more flexible and more enjoyable. Use it to wow your clients and take the headache out of planning and organizing, hunt out the best apps for the specific tasks you need it to complete. The App Store's photography section should be something you check out on a weekly basis, see what's hot and what's new and experiment with free or trial apps to see if they work for you.

I hope this book has provided you with some great ways in which to use your iPad and I hope you continue to refer to it as and when you need inspiration or advice. You never know when you might need to try something different on a shoot and the iPad's screen and connectivity options provide a wealth of opportunities if you harness the right application. While the book won't teach you how to take better photos, it will help you to access, edit, and share them better and, if anything, I hope it has reaffirmed your faith in your decision to buy an iPad in the first place.

iPad Models

So you're ready to buy yourself an iPad and change the way you work with photos forever. Or perhaps you're already using an iPad but are thinking of an upgrade. Either way, the first question you'll be asking is "Which one do I buy?"

While there are only two different models of iPad—the Wi-Fi and Wi-Fi and 3G—there are three different sizes available for each; 16GB, 32GB, and 64GB. As with most things, the more money you spend the more features you get. Fortunately, in the case of the iPad, the decision is simplified by the nature of the iPad's price-dependent specifications, namely its capacity and Internet connection. If you can do without a web connection wherever you are and can handle a device that will only be able to hold a handful of photo shoots, by all means opt for the cheapest iPad.

You must, however, look at the investment you're making and question whether the added storage and omnipresent Internet connectivity would be worth the money in the long term. If you fall into this category, go for the iPad line's top end. Do bear in mind that the 3G iPad's cost does not end when you leave the store; a monthly tariff from one of the major networks is also required for Internet access. The monthly cost is comparable to a pay-as-you-go mobile phone service and allows a certain amount of data to be used per day or per month. As a rough guide from the networks, 1GB of data allows you to browse the web for 10 hours, send 1000 HTML emails, download 32 four-minute music tracks and five four-minute videos. You will also need to bear in mind how much of the time you'll be using a Wi-Fi network (which is free) versus your 3G connection and also cater for the difference in speed between the two. For a photographer, the 3G option could be as simple as just having it available for browsing or it could be a permanent fixture in your day-to-day work.

INDEX

MESSAGES FROM THE PUBLISHER

Keep up to date

Due to the fast-paced nature of techonology development and the iPad's ever-increasing array of features, available apps, and updates, some of the information in this book may become out-of-date.

However, we as the publisher want to keep you as current, informed, and up-to-date as possible, and to this end we've dedicated a portion of our website to *iPad for Photographer's* updates. Check www.web-linked.com/ipad for any information regarding new releases.

The Ilex Photo Tool for iPhone

The Ilex Photo Tool for iPhone, iPod touch, and iPad, is a very handy 4-in-1 tool for digital photographers trying to get the best out of the portable camera on their iPhone.

Building on Ilex's heritage as a leading publisher of photography books, the Ilex Photo Tool offers quick and convenient access to everything the photographer needs to get the perfect shot, straight from their pocket.

To learn more and download today, visit the Ilex Photo Tool page on the iTunes Store.

ACKNOWLEDGMENTS

Throughout the writing of this book I have sought the opinions and advice of a wide range of professionals across many disciplines. From photographers to journalists, software developers to web designers, their help has been invaluable and I thank each one of you. Special thanks should go to Corey Rich for refusing to let 10,000 feet and time zones prevent his contributions and to Frederick Van Johnson for putting up with one of the longest email chains I have ever been involved in. Also, thanks should go to the wonderful and understanding Hayley Shore for putting up with the late nights, constant keyboard tapping and my endless out loud thinking.

Ben Harvell 16 June 2011 12:20